Painting Landscapes in Watercolor

Painting Landscapes in Watercolor

BY ROWLAND HILDER

Paperback Edition 1985

First published 1982 in the United States and Canada by Watson-Guptill Publications, a division of Billboard Publications, Inc., 1515 Broadway, New York, N.Y. 10036

Library of Congress Catalog Card Number: 81-24068

ISBN 0-8230-1617-X ISBN 0-8230-3654-5 (pbk.)

All rights reserved. No part of this publication may be reproduced or used in any form or by any means—graphic, electronic, or mechanical, including photocopying, recording, taping, or information storage and retrieval systems—without written permission of the publisher.

Manufactured in Japan

1 2 3 4 5 6 7/90 89 88 87 86 85

ACKNOWLEDGMENTS

I would like to thank David Lewis for all his patience and encouragement, as well as for his contribution to the planning of this book; Betty Vera, who edited the text; Bob Fillie, who designed the book; Hector Campbell, who supervised the graphic production; and especially Rado Klose, photographer, for his prolonged efforts to achieve perfection in the color rendering of each picture—no mean feat when faced with recording stages in the development of a watercolor painting.

Contents

HOW TO USE THIS BOOK 9
INTRODUCTION 10
WHAT IS A GOOD PAINTING? 14
VALUE 16
ADDING TONE TO LINE DRAWINGS 18
USING TINTED PAPER 20

PART ONE: PAINTING SKIES 22

USING AERIAL PERSPECTIVE 24
ESTABLISHING VALUES ON A TONED BACKGROUND 25
ADDING COLOR TO TONE 26
DEVELOPING TONE WITH COLOR 27
SCRUBBING OUT SKIES 28
PAINTING DARK CLOUDS AGAINST A LIGHT SKY 29
DEFINING SOFT WHITE CLOUDS AGAINST A BLUE SKY 30
PAINTING WARM CLOUDS ON A COLD SKY 31
CREATING HIGHLIGHTS 32
CREATING SMALL WHITE AREAS 33
PLANNING WASHES FOR A COMPLICATED SKY 34
PAINTING A HEAVY GRADUATED SKY 35
COLOR AND PALETTE 36

PART TWO: CAPTURING ATMOSPHERE AND MOOD 40

RETAINING CONTROL IN A LOOSE TREATMENT 42
CREATING A STRONG BUT SUBTLE SKY 48
BALANCING AREAS OF BRIGHT LIGHT 56
RETAINING IMPACT IN A QUIET PAINTING 64
CREATING MOOD 72
CAPTURING MOVEMENT 80
VARYING THE TONAL PATTERN 88
UNRAVELING A COMPLEX SUBJECT 98

PART THREE: GALLERY 108

INDEX 142

How to Use This Book

The aim of this book is to help you capture atmosphere in your paintings of the land, sea, and sky. To do this, I have divided the book up into three parts.

First, there is a section on painting skies. Here I suggest you study the simple, three-stage studies and demonstrations and then try each one for yourself. It is probably a good idea to keep these exercises small so that you do not have to worry about handling large areas of fickle watercolor and can concentrate entirely on the subject or technique at hand. Make your own variations on each theme so that you can incorporate it into your own painting methods in due course. These sky exercises are not the only ways to handle light and clouds but in my experience they are the most direct ways of capturing the delicate characteristics of the most influential part of almost every outdoor painting.

Next, there are eight full demonstrations. In each of these, I explain how to

handle a subject or mood that is an exciting challenge and presents some of the trickier problems you are likely to encounter. I use many thin watercolor washes to obtain subtle variations in value and color, and the stages of the demonstrations are reproduced across two pages, often with an additional detail, so that you can study these washes closely. The demonstrations show you my working methods. If you consider each one objectively, you can see how I think about a subject before I paint it and how I break it down into a manageable sequence of watercolor procedures. I firmly believe that many paintings are ruined before they are even begun; as an exercise before starting each painting, I advise you always to think about what you want to show, decide the focal center of interest, and consider what is important and what can be played down or left out altogether. Technical painting skill is necessary to make good pictures and it is

essential to master handling pigment and water on paper, but I urge you not to let technical skill overcome a thoughtful interpretation in your quest for successful watercolor painting.

The final section is a selection of some finished paintings. There is nothing particularly special about any one of them, but each painting gave me a warm sense of satisfaction upon completion. I have kept technical information to a minimum here, in order to encourage you to concentrate on the overall painting as a finished interpretation. These paintings are my way of seeing. Recording the elements in watercolor has given me an enormous amount of pleasure over the years, and although it always demands effort and concentration, for me it has never become "plain hard work." I hope you will find this book a help and encouragement to develop your own way of seeing and interpreting with watercolor.

Introduction

I think the process of learning to drive a car is a good analogy for the way a painter learns to develop confidence and ability. When starting to drive, you need to learn exactly what the pedals and levers will do when operated, in which order they should be applied, and just how much they should be used. The same is true of watercolor. You need to understand the capabilities of brush, paint, water, and paper, the order in which to apply paint to paper, and with how much strength. Driving and painting both become automatic

processes between the mind and the hands. In time, you do not have to think about *how* to work the brakes or *how* you apply a wash; you stop the car at the red light and lay in a wash of neutral tint that suits the sky you wish to paint. Your hand responds to what your eye sees.

This is a crude analogy, however, when it is examined more closely. One year of driving practice will not make you a Grand Prix racing driver, but you will be able to control a vehicle unconsciously and become a reasonably

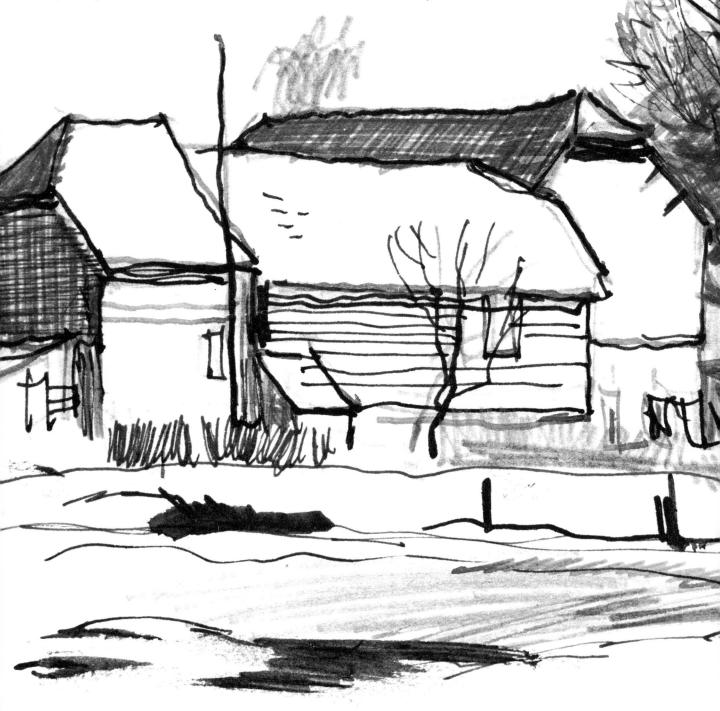

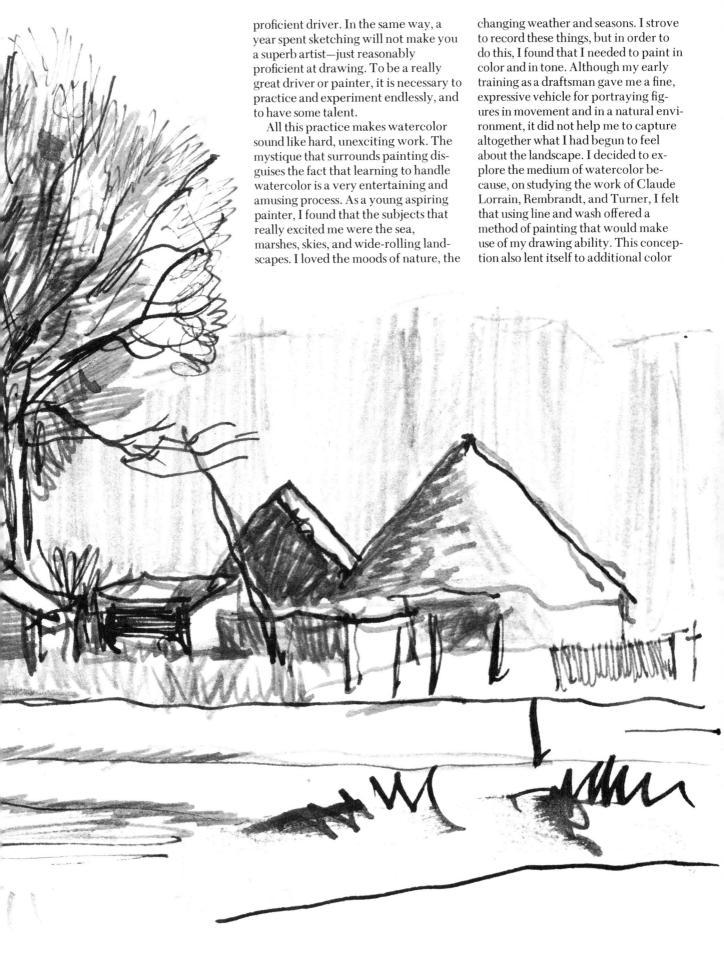

and tone. Yet I could find no one who could initiate me into the mysteries of watercolor painting! And so, having made a spectacular start with the help of a brilliant drawing master, I was now reduced to the slow process of teaching myself watercolor technique.

In practice I found that again and again, I tried to rescue a watercolor by adding unnecessary line drawing in an attempt to retrieve a dismal failure. And so I was forced to discipline myself to the process of making pure watercolor paintings that did not depend on the saving grace of additional line work. Here I was confronted by the mysteries of tone and a hundred and one problems I had not even dreamed of. I began a long and dreary process: the examination of numerous pigments by making hundreds of color brushings. I made abortive attempts to paint scenes on location, all bearing the mark of the most abject amateur. After such an exciting start, what a dreary and humiliating comedown!

Yet I felt so strongly about what had become my choice subject that I was doggedly determined to continue. Where could I seek guidance? All London art schools seemed to ignore the one subject I wished to learn about. Courses were offered in life drawing. portrait painting, design, pedagogy, art history, silk screen, wood engraving, occupational therapy, and potato cuts. There were lectures on the Bauhaus, abstract painting, how to make mobiles, and the art of assembling discarded junk to create esoteric sculpture. Anything, but anything, except even one simple class in the great traditional art of watercolor painting—the one art form in which it was said the English led the world!

I began a series of experimental brushings for two reasons. First, to find out which pigments were successful and relatively free from a muddy appearance when used for the darker tones. Second, to see if I could gauge the right depth of color in one attempt. My aim was to avoid having to achieve the deeper tones by overpainting.

The next series of experiments I made involved the mixing of colors to ascertain the various hues available at different tone levels. Here I found many surprises. For example, I discovered I could mix "Constable" greenthe color of trees in high summer-not by taking a known green straight from the tube, nor by mixing vellow and blue as we had been taught. I simply mixed lampblack and cadmium lemon yellow. Deep green has always been a problem in watercolor because to begin with, a bright yellow is a very light-toned pigment. It's easier to get a deep green with a blue hue. I found I could do this by mixing phthalo green with burnt sienna, burnt umber, or sepia.

Through these brushings, I found that pigments behaved in many different ways. Some were relatively opaque, while others were transparent. The earth colors formed readily into groups and when heated, tended to turn red. Thus, calcined yellow ochre became light red, raw umber became burnt umber, and raw sienna became burnt sienna. I found that the siennas were much more transparent than the other earth colors, and that raw sienna made

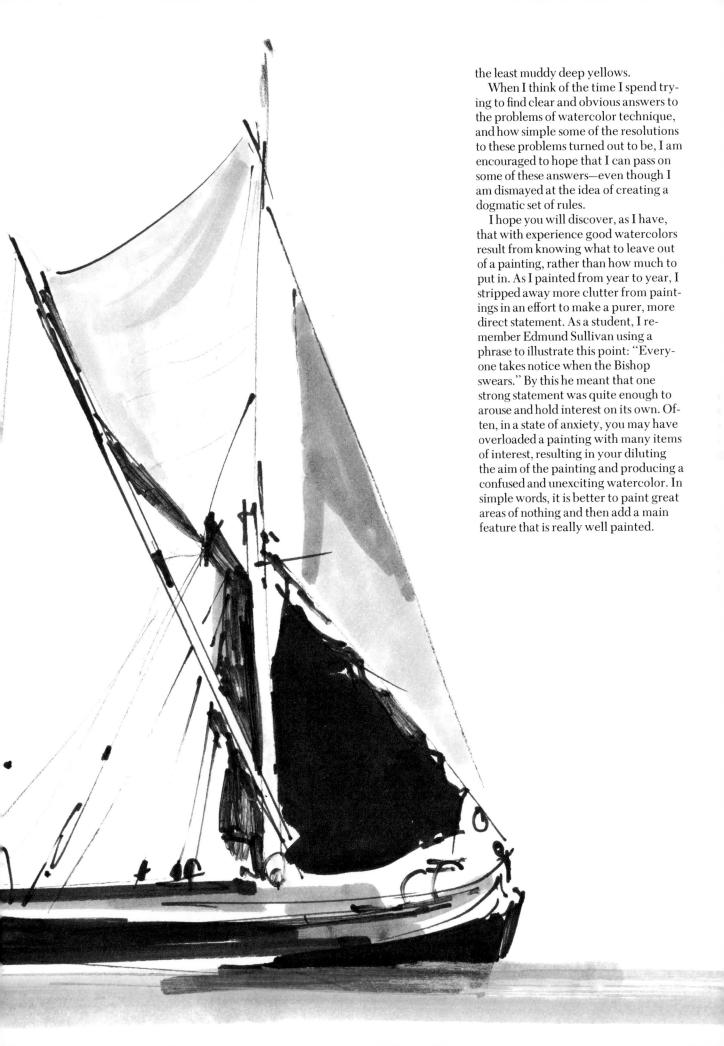

We would all like our paintings to be good, but how can we judge them?

We can seek expert opinion. Numerous books, articles, and art courses offer instruction. We are told what brushes, mediums, and solvents to use; about supports to paint on; how to view a scene, how to mix colors and block them in, and about methods of application. But, having produced a picture, how can we decide who is to be the judge of its merit?

A high court judge once asked during a trial, "How do we know that this is, in fact, a valuable work of art?" The reply was, "It is the consensus of informed opinion, M'lord." That seemed to settle the matter. Nobody bothered to ask about the curious body of experts that were considered to be informed, or how they had been informed, or even if anyone was able to inform them!

Perhaps we are all ready to accept the idea that some kind of objective, omnipotent opinion about art affairs does, in fact, exist and which, like the umpire's decision in a game, must be taken as final.

If we turn for help to the television and newspaper critics, pundits and esoteric art writers, or to the self-styled taste makers, we are confronted with a conflicting and rapidly changing expression of opinion. We are told that art should reflect contemporary life, but then again, that it should be non-representational; that art should be abstract and free from the expression of opinion, but that it should have a social consciousness; that the painter should engage in social realism; and that good painting is always iconoclastic.

When we read these conflicting pronouncements, we are already out of date, because art has since become a happening or a soup can. By this reckoning, we might begin to aspire to the contemporary if we see painting as being concerned with the mechanical enlargement of some bland photographic detail, or as a grossly enlarged portion of a run-of-the-mill cartoon.

Over a short space of time, the fashionable scene of the art critics jumps from movement to movement, and we are confronted with an ever-extending list of clichés and art terms. We move from Impressionism to Post-impressionism and on to Expressionism, then to Futurism, Fauvism, Naivism, Surrealism, Dada, Op Art, Pop Art, abstract art, Action Painting, Non-art, Anti-art, Functionalism, Constructivism, and so on, and on, and on.

Art writers like to portray artists who live in poverty; go mad; cut off their ears; pine away with tuberculosis; die of starvation, syphilis, poverty, or leprosy; or commit suicide in squalor. All this makes good and profitable reading.

We are also treated on occasion to a bout of "cocktail party psychoanalysis." I recently came across an example written by an eminent "critic"

who describes at some length what he considers to have been the working of Turner's "unconscious" mind. In short, Turner's wonderful paintings of the moods of nature, his great pictures depicting the sea, skies, and atmosphere, together with his use of color-particularly scarlet, orange, and vermilionwere due simply to his childhood experiences in his father's barbershop! Thus, the great seas in Calais Pier (where Turner nearly drowned during a gale) were nothing but the childhood memories of froth and lather as seen in the barbershop. Sunrise Through Vapour is but candlelight seen in a steamed mirror. Best of all (according to the writer), Turner's use of orange, red, and pink are attributable to the sight of blood from shaving cuts flowing into lather.

A few weeks ago, I listened to a talk on the radio about Schubert. "At this point," said the speaker, "Schubert introduced into the bass the deep, sonorous tones of the horns. It has been said that Schubert did this in anticipation of his own death within the year." Then the speaker added, "Why can't we just forget all this and simply give credit for fine craftsmanship and appreciate the beautiful sound of the orchestral arrangement?" And so with our painting. Why not just ignore the dogmas that surround the arts today? Why not just enjoy doing and looking at paintings and cherish the mood evoked by painting that turns us on?

A picture is not necessarily better because it is an abstraction, or because it is larger, or more expensive, or because it follows the dictates of the latest fashion in art. When all is said and done, the quality of a work will depend on whether it conveys a significant mood or expresses a quality of beauty, or whether it can open the doors of visual perception.

While it is difficult to think of fine

painters who do not command a thorough knowledge of the technique of expression, some of the greatest artists often conveyed intense and beautiful feelings using the simplest of means. Certain pictures by Whistler, John Cotman, and Turner come readily to mind.

One rule that I do agree with is that the essence of good style is the art of making a clear, simple, direct statement. Watercolor is a responsive medium ideally suited to combining the great tradition of direct drawing in line with the art of painting in tone and color. Once you have embarked on the pursuit of watercolor painting, then surely you might as well lose yourself in the sheer enjoyment of the work and forget the dogmatic pronouncements of the pundits and taste makers. I have spent over fifty years painting the land, the sea, and the sky, and I still feel pure and simple exhibaration with each new painting I begin.

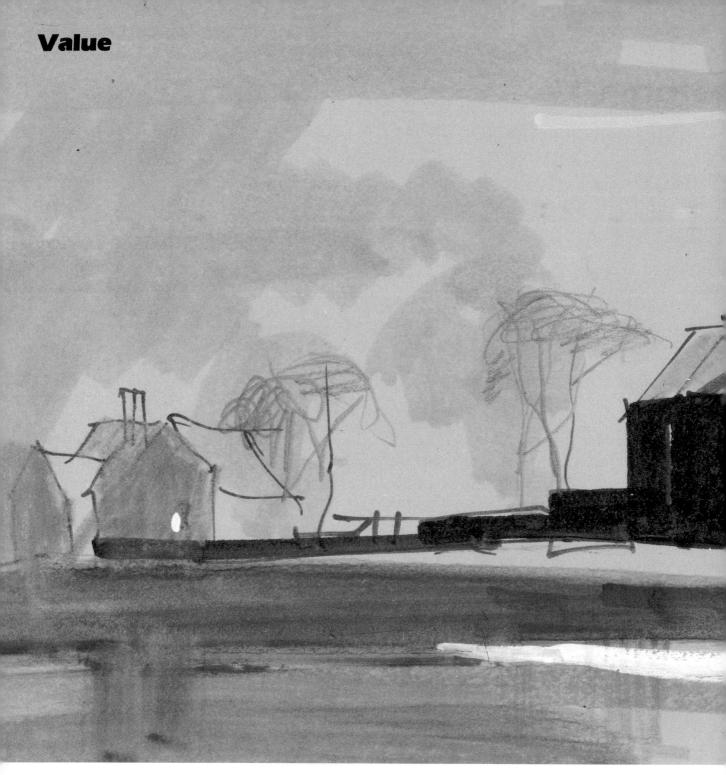

To paint good, full-valued pictures, you must train yourself to see the things you wish to paint as a series of tonal areas and shapes. The great difficulty with this, though, is that the tonal scale of a real scene is infinitely greater than the very limited range available to the painter who has, after all, nothing darker than black pigment and nothing lighter than white paper or opaque white paint.

Most of the great painters conceived their subjects by setting them against a basic halftone background. Against such a background, both darker and lighter shapes will stand out clearly. This is why so many artists prepare for making a painting by doing numerous small sketches on toned paper—using, for example, line and wash for the passages darker than the background tone and an opaque white paint or pastel for the white or lighter areas. Turner made numerous sketches on tinted paper using black and sepia for the darker passages, and chalk and body-color white for the lighter ones. The study of such sketches is often of great value, as they

can reveal how the artist planned the tonal arrangement for a painting.

Faced with the very large range of tones you see in nature, and with the problem of transcribing relative tonal values to bring them within the range available in paint, you will find it worthwhile to try various aids that can help to reduce or condense nature's full tonal range.

The easiest way of cutting out extraneous light is simply to view the scene through half-closed eyes. However, perhaps the most effective known aid is

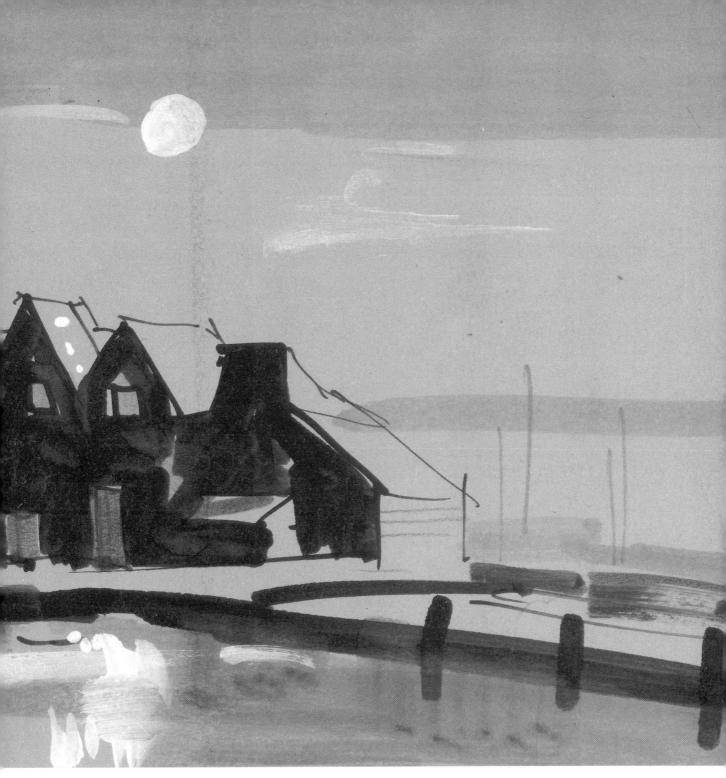

the Claude mirror. A simple version of this can be made simply by painting a piece of smooth clear glass black on one side. When you view a scene reflected in this darker surface, the values will have lost nearly all of their color; this makes them easier to see. I made my own Claude mirror by using a small unwanted picture frame, painting the inside of the glass with black acrylic paint, and replacing it in the frame with a secure backing to protect it from abrasion or scratching. The original

Claude mirror was, I believe, convex, giving a wide-angle effect. I have a beautiful little Claude mirror that was made for me by a student using a car's rear-view mirror. I have in mind to purchase a thick sheet of black plastic (perspex in England), which will make a lightweight mirror that is less liable to break than glass.

The first time you use a Claude mirror, you will be astonished at the beauty of the reflected image. Dark scenes will, of course, lose out, but

brighter scenes respond admirably, and skies in particular look most paintable.

One famous teacher who advocated painting by the tonal method recommended using several sets of dark sunglasses. In his view, the process of painting was to record the shape of the lightest area, remove one set of sunglasses and record the next lightest tone, and so on down the tonal scale. This is a method he used with students painting in oil, and I am told it is most revealing.

Adding Tone to Line Drawings

When making sketches outside, add tone in any way that you can to achieve the desired impression. When back in your studio, you need to have an accurate record of the balance and scale of values, in order to capture the mood of the scene as it was when you were originally attracted to it.

Each of these four drawings was made with the only medium I had available at the time, yet each works as a precise record. Even the ball-point pen, which is a hard, insensitive drawing instrument, produced a small amount of charm.

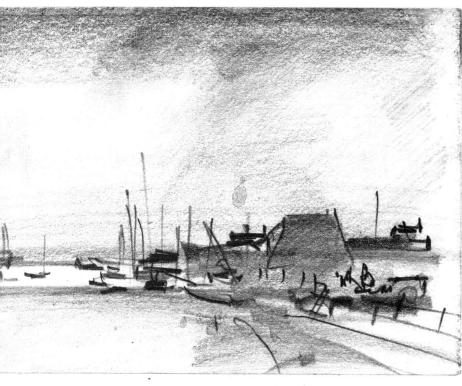

This sketch was made with a 2B pencil. I made the sky values by using soft pencil strokes that I smudged with a finger. The line drawing conveys a slight impression of the scene, whereas the pencil hatching explains the light and atmosphere quite clearly.

I made this doodle from the window of my car. The blacks were produced with a thin marker pen and some of the line work was done with a ball-point pen. Even though it is a coarse drawing, it is a useful note for studio work later.

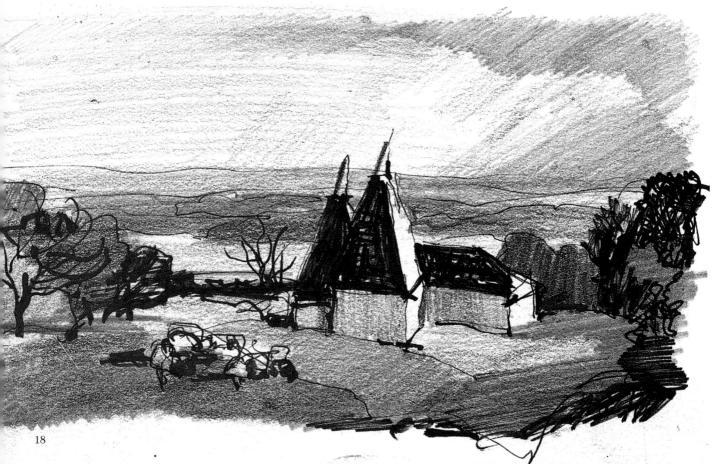

Here, I used a ball-point and a black marker. The sky is crudely hatched with the ball-point, with some additional description of cloud shapes superimposed.

Although I used pencil hatching to describe the full sky on this showery day, it was the borrowed non-water-proof marker pen that gave the watery values to the foreground. I wetted down the areas drawn with this instrument, and the ink moved freely in a diluted state.

Using Tinted Paper

One of the simplest and most effective ways of recording the atmosphere of a particular landscape is to make all preliminary sketches on tinted paper. Turner kept a selection of sketchbooks with pages that had been prepared with tinted background washes. When out sketching, he was able to turn to a page primed with any one of these tints: a selection of light grays, oranges, yellows, blues, blue-grays, and purplish blues.

The sketches on these two pages were made on location at an old tidal mill, using a brown-tinted Ingres paper. They were all made rapidly as I moved from one place to another, trying to capture the mill and quayside atmosphere. I used casein for the whites, lampblack for the washed-in values, carbon pencil, and a handy ball-point pen to sharpen up the focal objects. I touched in the light areas of sky with a white Conté crayon. I find the assessment of tones with this method of interpretation tremendously exciting, and I urge you to try it for yourself. It is extremely simple and direct and produces drawings that are strong statements by themselves.

PART ONE

Painting Skies

I remember that when I was a student of watercolor, I read one piece of advice that has probably helped me more than anything else: "Paint a sky a day." I happened to latch on to that one short, simple statement in a book by Alfred East, one of the great masters of his time.

Think about it. If you look out of the window at any time of any day, there is always a different value or color of sky to paint. Compare the view from a north window to that from one facing south, and see how the intensity of light varies. I urge you to make it a routine to paint a sky every day. This will build your confidence and ability—and with continual practice, you will learn how skies form and break up; understand

cloud formations and how they filter, diffuse, and soften light; and be able to gauge overall values with comparative ease. I practiced this myself, and in a short time, I learned to paint skies simply. As a painting subject, the sky provides a wonderful playground for learning to control a wash, developing an understanding of color intensity, and being able to recognize drying properties of pigment and paper.

On the next few pages are some simple demonstrations that analyze sky formations and show how to paint them in the most direct and effective manner. I learned all these techniques the hard way; try them out yourself and then put them to use in your own sky painting.

Cley Mill, Norfolk, 22" x 30" (56 x 77 cm)

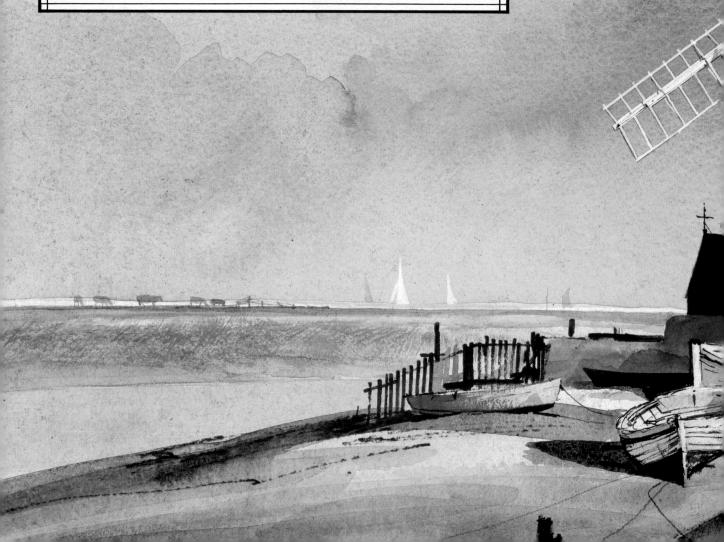

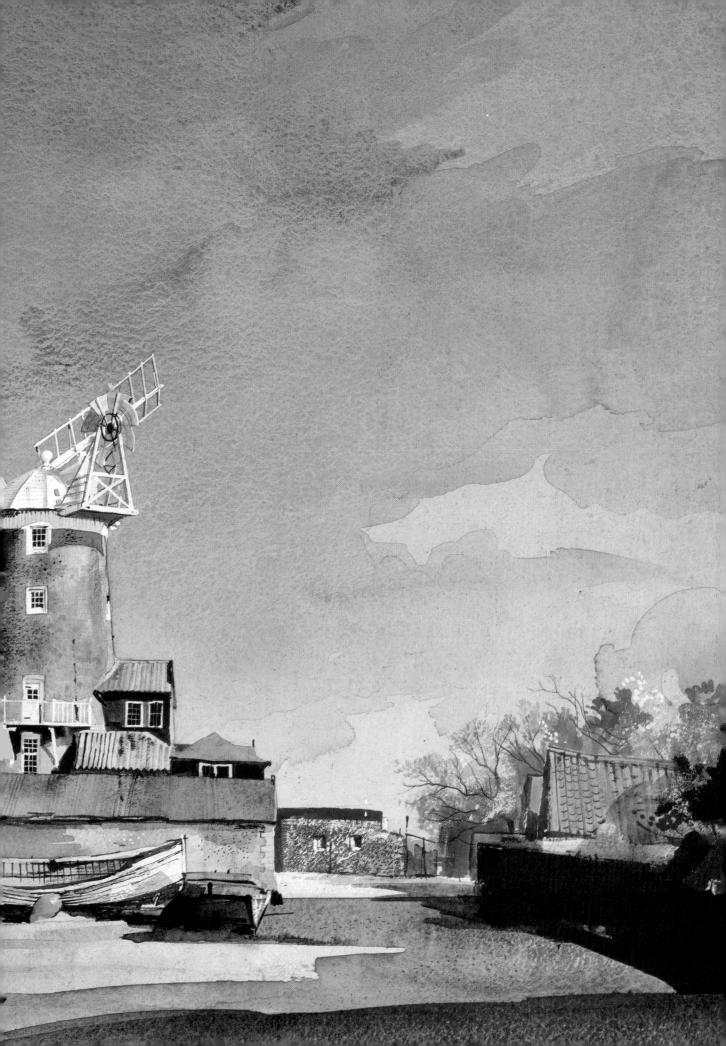

Using Aerial Perspective

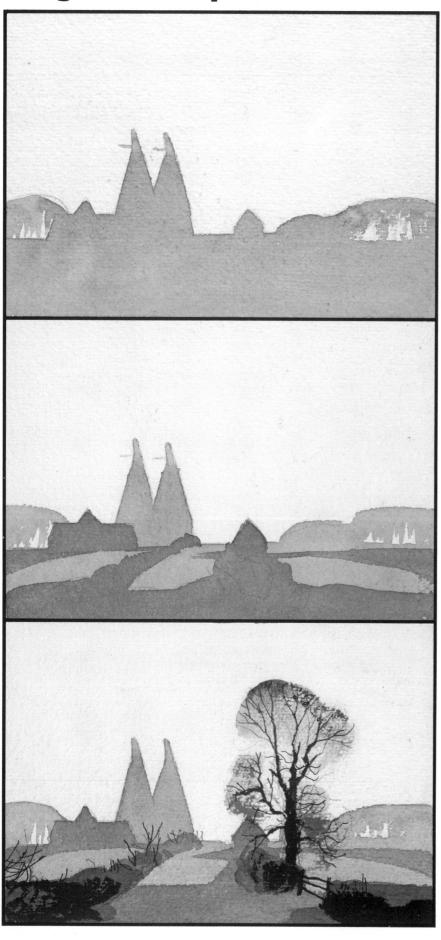

This exercise illustrates how you can achieve the effect of receding space by using dark values in the foreground and light values in the distance. This is one of the most basic techniques in watercolor, as it helps to create the illusion of a third dimension better than any other device.

- 1. Each stage has just one wash. Make the first one a light mid-value and apply it flat across the paper to indicate the land and the silhouettes of the buildings and other shapes against the light sky.
- 2. When this is dry, mix a darker midvalue for the foreground, the shadowed areas of the middle distance, and the nearer buildings. Every object in the picture is depicted as a simple, flat cutout shape and occupies its own position in space, but the lighter shapes at the horizon appear to recede.
- 3. Now draw the details of the large tree and foreground brush in the darkest value. Notice that the gray silhouette wash of the first stage, which appears as a dark shape against the light, also serves in part as a sunlit portion of the lane in this stage.

Establishing Values on a Toned Background

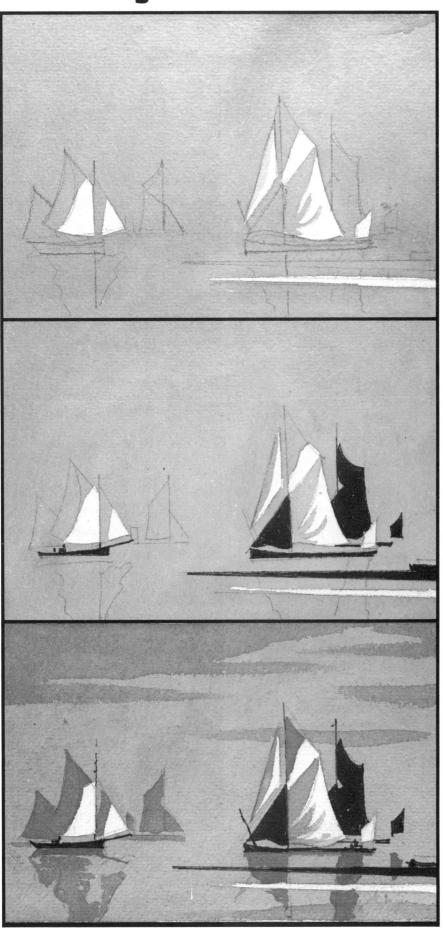

If you wish to paint a brilliant white object, such as a sail, then it is essential to establish a toned background against which the lighter tones will register. Remember that the darker the background, the more the white areas will glow by contrast.

- 1. Mix a light mid-value for the background sky and water. Outline the ships and then paint the wash in as a flat, even value, leaving the white areas unpainted.
- 2. Now add the darkest tone, in this case black. All the additional values will fall between the two extremes you have established. Already, the whites stand out really well.
- 3. Mix a dark mid-value and add the remaining features, such as distant boats, sails, and reflections. With just four values, you have made a credible sketch.

Adding Color to Tone

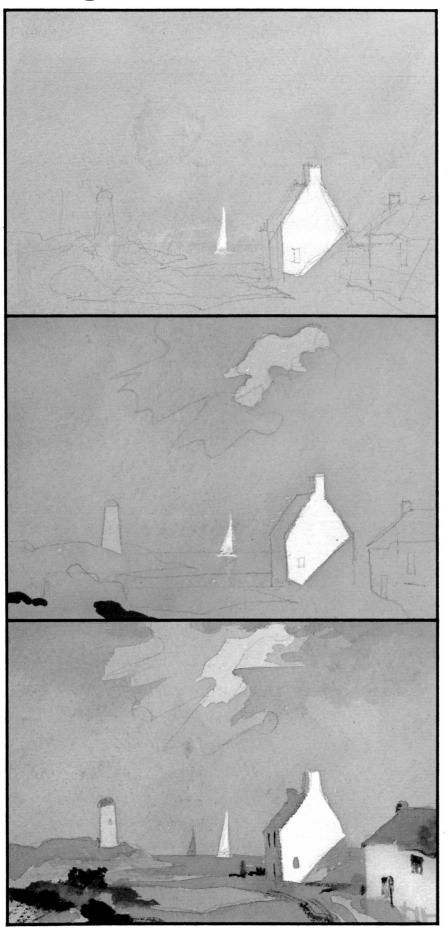

- 1. Make a rough outline indicating the scene. Then lay a wash of lampblack over the paper, leaving the whites to stand out. Aim to show that the house is whiter than the sky.
- 2. Lay a second wash of the same color over the entire surface of the paper, except for the cloud and the lighthouse. Put in two areas of black to establish the darkest tones. Leave it to dry.
- 3. Add a wash of blue, starting at the top of the picture and graduating it from dark to light. Let it dry and then add blue to the sea. Add some foreground details with dark gray, aiming simply to establish tonal harmony. A few strokes of black make the necessary accents.

Note that the lightest cloud appears to be white, although it is a whole tone darker than the house.

Developing Tone with Color

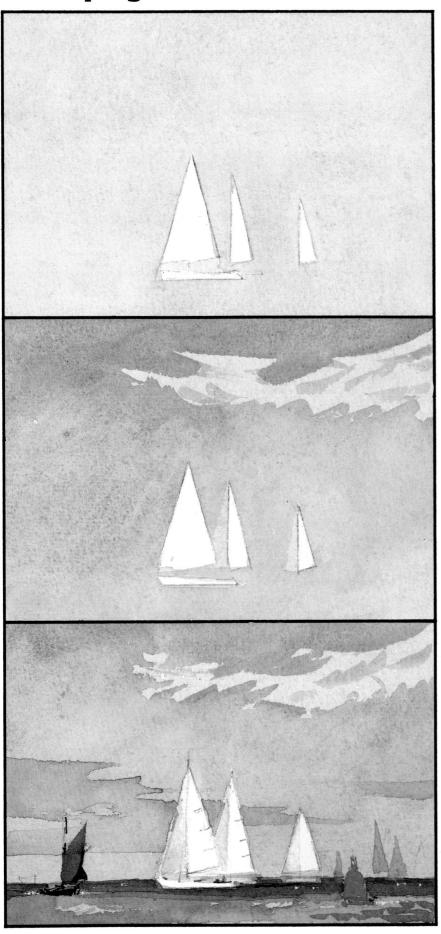

- 1. Mix a wash of alizarin crimson and lampblack and lay it flat across the paper, leaving the white boat sails unpainted. Leave it to dry.
- 2. Add a wash of blue, graduating it downward from dark to light and leaving just a few hard-edged shapes high in the sky.
- 3. Add the lower strips of dark cloud with a pale wash of neutral tint. Use this color in greater strength for the sea, black and burnt umber for the foreground fishing smack, and a touch of bright color for the buoy. Flick out some wave crests with a sharp knife.

Scrubbing Out Skies

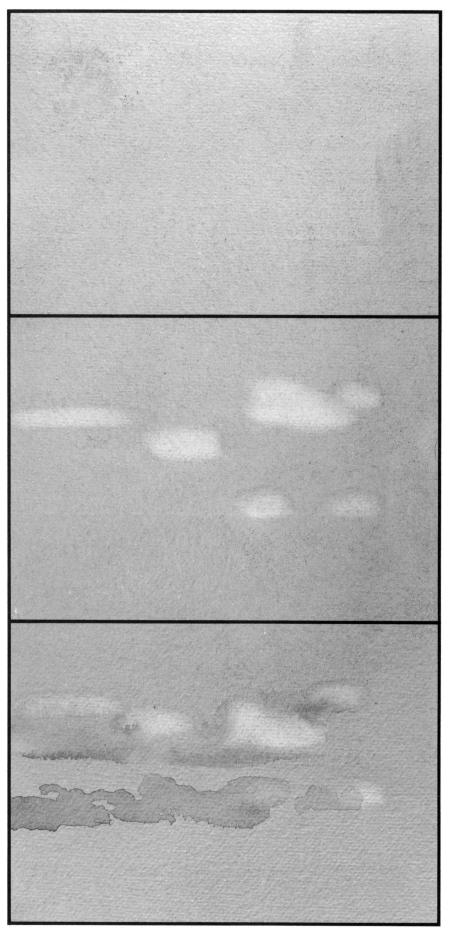

- 1. Apply a perfectly flat wash of lampblack over the paper and let it dry.
- 2. Use a stiff hog-bristle brush to scrub out the light areas and immediately blot away all excess moisture with paper towel.
- 3. Add a second tone of lampblack to the shadow side of the clouds, allowing the upper edge of the wash to diffuse into the moist surface of the light areas while the lower edge dries hard on your original wash. In this isolated context, this may look insignificant, but when used with care and integrated into a large sky, it creates an extremely realistic effect.

Painting Dark Clouds Against a Light Sky

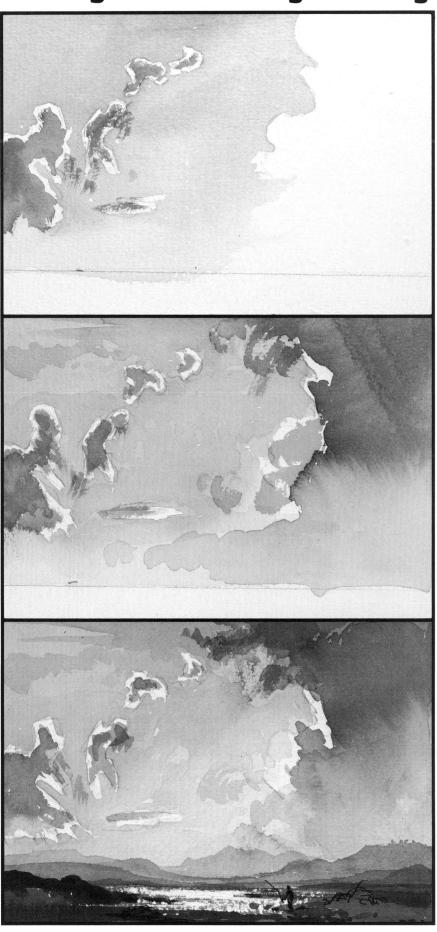

- 1. Paint the shapes of the dark clouds with a mid-tone of lampblack. When it is dry, paint a lighter wash of lampblack over that portion of the sky, leaving a white edge between the two tones of lampblack.
- 2. Add a graduated wash of Winsor blue, working downward and leaving areas of the original gray color. Add a deeper wash of lampblack to the clouds on the right-hand side, graduating carefully so that they appear lightest at the horizon.
- 3. To turn these random tones into a sky above a landscape, add receding tones of neutral tint for mountains, with some black to indicate rocks and a fisherman in the foreground. A little burnt umber will add warmth to the range of colors and will balance the weight of the tones in the upper and lower portions of the picture.

Defining Soft White Clouds Against a Blue Sky

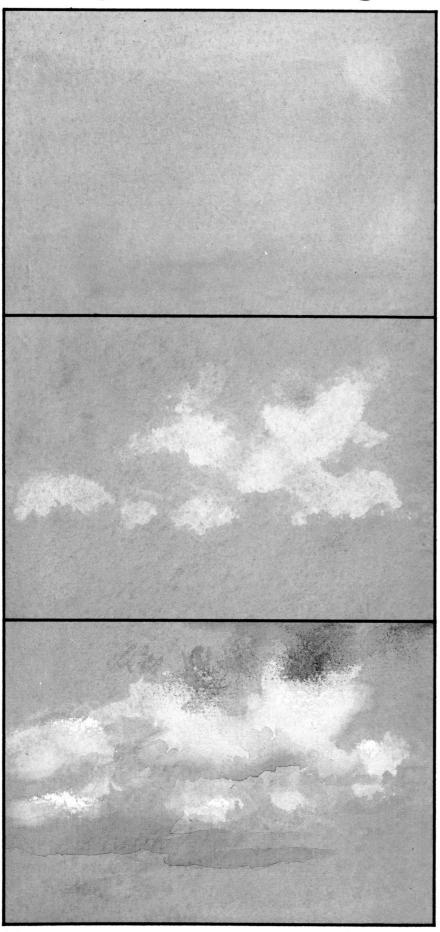

This simple and fascinating exercise is a development from a basic technique. It is particularly suited to painting skies.

- 1. Mix a wash of medium strength from phthalo and cobalt blue, and paint it evenly across the paper.
- 2. While the wash is still wet, use a piece of absorbent paper towel to blot out white areas. In this example, my original wash was so wet that color began to creep back into the white areas, making continual blotting necessary to achieve the exact shapes of the white cloud areas.
- 3. When the wash is quite dry, add shadows to the undersides of the clouds with a warm gray made from neutral tint mixed with a touch of light red. Leave the wash alone at the lower edges of the clouds, so that it dries as a hard edge. Soften the top edges with a wet brush.

Painting Warm Clouds on a Cold Sky

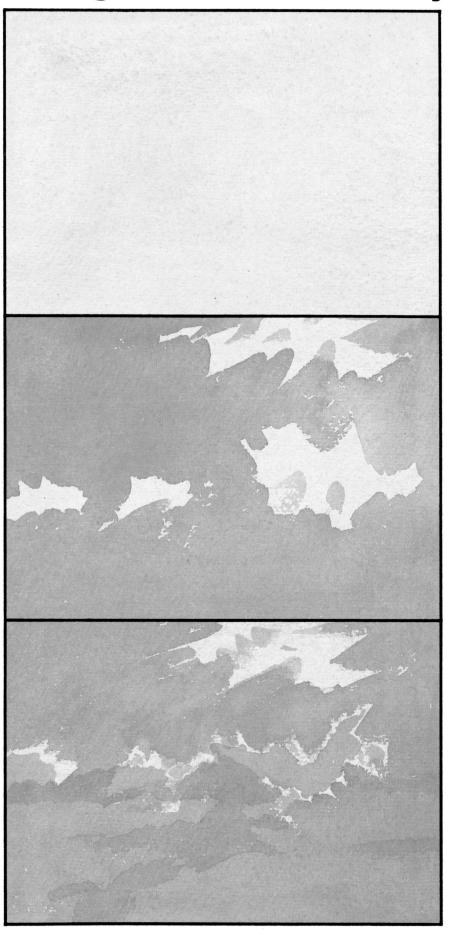

- 1. Lay a perfectly flat wash of very pale orange over the paper and let it dry bone hard.
- 2. Lay a flat wash of phthalo blue over the dry orange wash, leaving areas and flecks of basic orange wash to simulate wisps of broken cloud.
- 3. To establish a shadow side to the clouds, add a wash of thin lampblack in patches. When the lampblack is washed over the orange, it creates a much warmer color than when it is applied on top of the blue wash.

Creating Highlights

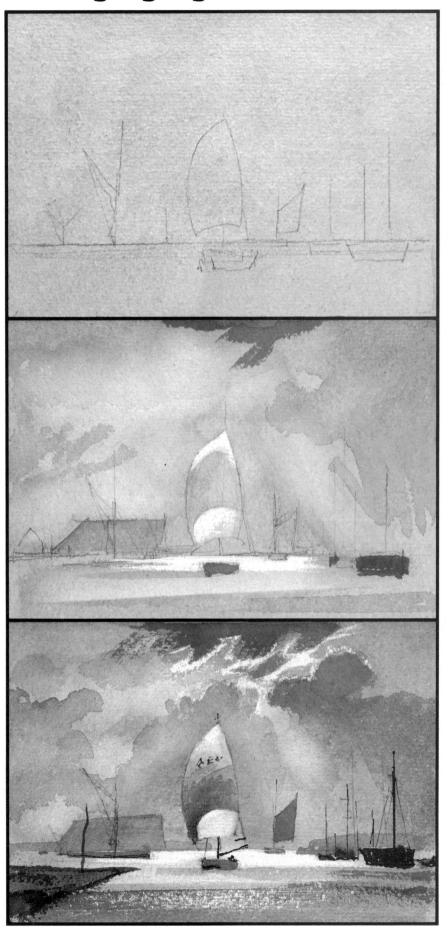

One of the difficulties inherent in the art of watercolor painting is the difficulty of establishing areas of white. While it is possible to paint around white and light-valued objects, there are times when it is impractical to do this. Here are some alternative ways of establishing light areas by removing color.

- 1. Indicate the main features of the picture lightly in pencil. Then put an even, flat background wash over the whole area.
- 2. When the wash is dry, use a small piece of dampened sponge to lift out areas of tone to simulate sunlight and clouds.

Now lay a thick piece of tracing paper over the shape of the sail in the center of the picture. Outline the lighter areas on the tracing paper, remove it to a cutting surface, and cut out the white areas with a fine knife. Now lay the stencil back over the sail and sponge away nearly all of the pigment from the paper. Do not use too wet a sponge, or water will seep under the edges of the tracing paper. Take special care not to sponge toward the cut edges of the stencil.

It is worth noting that the late Sir W. Russell Flint used this technique to paint the fine, detailed modeling on the figures in his famous beach scenes without disturbing the free, fluent background washes.

3. Use a fine stencil knife to scrape away the light areas of sunlight appearing along the edges of the dark clouds at the top of the picture, as well as to simulate the gleam of sunlight on the water.

In the foreground, I have made a notvery-successful attempt to create a mottled surface on the water by using a fine emery paper. This painting is really too small for this technique, but emery paper creates an effective granulated texture when used on a larger work.

Creating Small White Areas

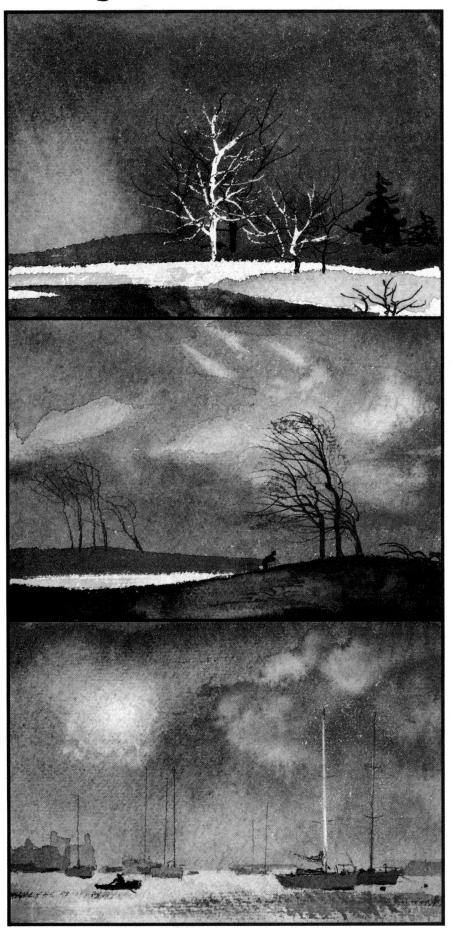

Creating a Resist with Masking Medium. Use a pen and masking medium to draw the white tree. When it is dry, lay a background tint of lampblack over the whole sky. When this is dry, add the dark trees with lampblack, using different strengths to enhance the illusion that they recede. Allow the study to dry bone hard and then rub away the masking medium with a finger, exposing the white paper underneath. Masking medium gives best results when applied with a fine pen nib. If a brush is used, it should be washed immediately afterward.

Scrubbing and Scratching Out Color. Lay a wash of lampblack over the entire paper surface. When it is dry, add a second wash, leaving an exposed area for the cloud on the left-hand side. When the second wash is dry, dampen the clouds on the right-hand side and scrub away some patches of pigment with a stiff bristle brush.

Add the trees when the whole sky has dried and then scratch out an area of bare paper to simulate water.

Sponging Out Small Areas. Lay a pale wash of lampblack over the entire surface of the paper. While it is still wet, lay another gray wash over it and then lift out parts with paper towel to create light areas. Leave it to dry.

Using a piece of cardboard to mask out the sky down to the horizon, sponge away the distant water so that the sea appears lighter than the sky.

Use this technique to create the white mast: Place two pieces of cardboard side by side, leaving a narrow space between them where the mast is to be. Press them down firmly on the paper and then rub away the pigment between them with a small piece of sponge. Remove the pieces of cardboard to reveal a thin white line.

Use a pale wash to draw in the boats, and draw the straight, thin masts with a lead pencil.

Planning Washes for a Complicated Sky

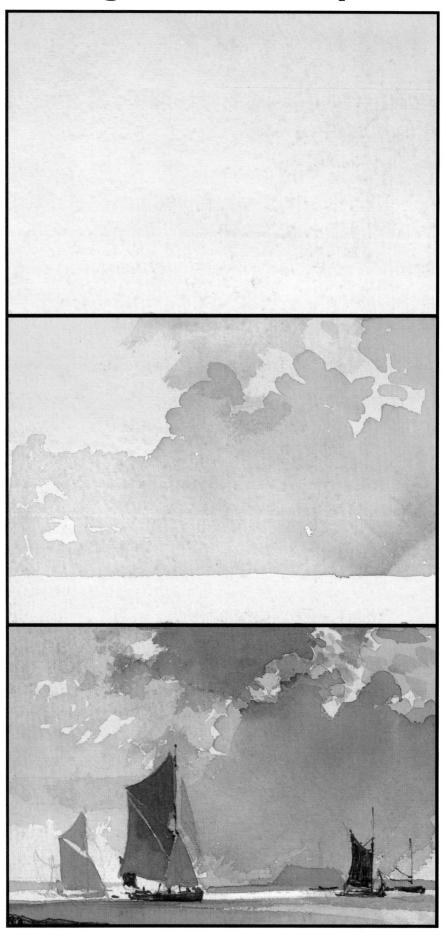

- 1. Lay a wash of raw sienna over the whole paper and leave it to dry bone hard. Then lay a graduated wash of orange over it, from top to bottom, and leave it to dry.
- 2. Add a trial tone of neutral tint, bringing it down to the horizon line. Leaving hard-edged lights, vary the tone a little by letting it overlap in places.
- 3. Intensify the clouds with washes of neutral tint, making the top cloud darkest to bring it forward. Add some blue to create the background sky, keeping it more intense at the top and leaving small areas of orange to indicate warm clouds. Put in the boats with burnt umber, and finally, scratch out the sunlight on the water with a sharp knife.

Painting a Heavy Graduated Sky

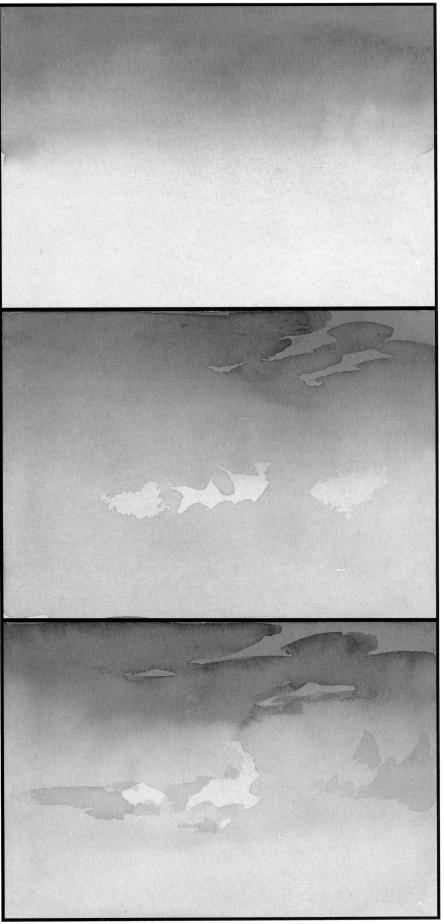

- 1. Lay an initial wash of yellow ochre over the whole paper. When it is dry, lay a strong graduated wash of lampblack over it, from the top downward.
- 2. Add a wash of phthalo blue from the top, leaving areas of gray to indicate high clouds in shadow. Let the lower part of the wash expose some patches (vary the hard and soft edges) of yellow ochre to indicate clouds in sunlight.
- **3.** Add some pale touches of neutral tint to indicate the shadow sides of the lower clouds.

Color and Palette

John Singer Sargent and Claude Monet used to go out and paint together. One day, Sargent is said to have left his paints behind and asked Monet to lend him his to work with. "Where's the black?" asked Sargent. "I don't allow myself to use black," replied Monet. "It's against the impressionist theory. In nature, all colors are made by mixing." Sargent refused to understand how anyone could paint without black.

Two great painters, each with entirely different views on color and mixing. Color is the most personal part of painting, for there is greater room for individual interpretation here than within the realm of value or line.

A BASIC PALETTE

Like most watercolor painters, when asked to recommend a palette I am inclined to advise just a few colors. On contemplating the working box in my studio, however, I am amazed to find that it contains some twenty-six colors! It seems that, like most things about watercolor painting, the subject is quite simple—but somehow quite complicated.

Obviously, one's palette must depend on what one wishes to paint and how one wants to paint. I use color to produce a harmony and to convey a mood rather than to reproduce the colors I see in nature. After all, if one only wants a faithful representation of an actual scene, then a color photograph will give a more accurate rendering than even the most accomplished painter could hope to achieve.

For out-of-door sketching on location, I find that a few colors will serve. Generally speaking, I aim to record the general tonal effect of the scene and to record the warm and cool colors. For this I can get down most of what I need simply using neutral tint and a warm sepia. If I wish to take a sketch further, I add burnt sienna, yellow ochre, and phthalo blue. I find I seldom need more colors when working on location.

Why, then, do I have so many colors in the studio? A good question, and one I find rather difficult to answer. Perhaps a simple answer would be that I like experimenting. However, on reflection I can find other reasons. I think one of the chief reasons is that different pigments behave differently—producing a variety of different physical qualities apart from tint, shade, or hue.

Granulated Washes. While a small sketch made on the spot can have a fresh, dynamic quality—it is almost impossibly difficult to keep this quality in a larger finished work. For this reason I seek the help of the surface quality and texture that can be obtained by using certain pigments. For example: when French ultramarine blue is mixed with a heavy opaque pigment such as light red or Indian or Venetian red, the mixture tends to separate out, producing a speckled granulated wash. Such a mixture, consisting of a warm and a cool color, can be made to produce an attractive broken surface that gives added interest to a large, otherwise unbroken tone.

The granulated effect occurs, I am told, because heavy opaque pigments suspended in water tend to sink and settle when applied to a flat surface. To obtain a marked granulated effect, one must make sure the painting surface is horizontal so that the wash will become a puddle, allowing the pigment to settle and granulate. While the wash is drying, the areas of settlement can be controlled by rocking or slightly tilting the board. It is quite fascinating to watch colors separate and settle under one's control.

I believe that the student of watercolor painting will find that different pigments vary in the way they behave during the process of application and during the period of drying out. I find that certain pigments, such as cerulean blue and ultramarine blue, respond well in the lighter washes, particularly if made to granulate; but being opaque, they become heavy and muddy when used for the darker areas.

Transparent and Opaque Colors. By and large I find the colors divide into two main groups: the really transparent colors and the opaque colors. The opaque colors tend to granulate but only serve well in the light and medium-toned washes, whereas the transparent colors look good in either light or dark tones.

Here is my list of transparent pigments, all of which are useful for the low-toned areas:

> Raw sienna Burnt sienna Sepia Alizarin crimson Lampblack

Payne's gray Neutral tint Raw umber Burnt umber

Since yellow is a light-toned primary color, it is difficult to use in the lower tone ranges. That is why the deep yellowish greens often seen in nature are so difficult to depict in watercolor. However, most of the pure yellows, as well as the following opaque colors, are useful in the lighter tones:

Yellow ochre Light red Terre verte French ultramarine blue

PERMANENCY

One thing that can be calculated to drive me crazy is visiting a famous watercolor collection where the pictures are set out in a darkened room or are secreted behind curtains. The explanation for this ritual is that it is hoped that the pictures will not fade if they are protected from the light.

I sincerely hope that future generations wishing to view contemporary watercolors will not be bugged by this rigamarole, for the watercolor painter of today has at his disposal a really splendid selection of light-fast pigments. Paint manufacturers offer two really sound lists of colors, one described as "permanent" (really light-fast) and the other, as "durable."

I try to test all my materials simply by drawing or painting a line of color across a sheet of paper and by masking one side and then exposing the other to the strongest light in my studio for a period of several weeks.

My tests confirm the manufacturers' ratings. The permanent colors are as follows:

Sepia
Lampblack
Blue-black
Charcoal gray
Davy's gray
Burnt umber
Raw umber
Burnt sienna
Raw sienna
Yellow ochre
Light red
Viridian green
Terre verte
Oxide of chromium

Cobalt blue Cobalt violet Azure cobalt Cerulean blue Lemon yellow

To this list I believe one can add French ultramarine blue, as I think this is only excluded from the above list because it can blacken if exposed to sulphur fumes. Today, however, with central heating, I would estimate the risk of this happening to a picture protected by a reasonably well-sealed frame is minimal. Likewise, I feel one could with confidence add one or two other "durable" colors.

One of the most important advances of our time has been the development of the Monastral dyes, which give us a range of beautiful blues and greens. Manufacturers are not allowed to use the registered name Monastral, and so these colors are sold under a variety of names. Thus, Winsor & Newton labels them Winsor blue, Winsor green, and so on, while Rowneys refer to them as Monstral blue, etc. These colors are perhaps most commonly known as phthalo blue, green, etc. For me the phthalo blue is a must, as it replaces Prussian blue, which is a fluctuating color that fades when exposed to strong light but regains hue when kept in the dark.

To this list I would also add alizarin crimson (rated as a durable color). There is a dearth of really permanent crimson and purples, and one must rely on some of the "durables." I carry a Winsor violet and a rose madder. Cobalt violet, listed as permanent, is a most difficult color to use in even a reasonably large wash—as is cerulean blue, a really beautiful permanent blue that is almost impossible to handle over large areas.

Grays. The traditional English water-color landscape is based on gray. The early watercolorists made their own grays from ivory black, which is warmer than lampblack; but because it is a product of calcined bones, ivory black is slightly greasy and is prone to unevenness on large areas of paper. Lampblack mixes more easily.

One ready-made gray I would be quite at a loss without is neutral tint (not made by every manufacturer—I use Winsor & Newton's). It is about the color of shadows, and I mix it with water to give a slightly cool gray.

When first marketed, both neutral tint and Payne's gray were mixtures of indigo, crimson lake, and lampblack. Neutral tint had a greater percentage of crimson lake and lampblack, while Payne's gray had a larger proportion of indigo. Crimson lake and indigo were not permanent, however, and today alizarin crimson and phthalo blue are used instead. Each of these basic shadow colors has a temperature, and I believe a thorough understanding of the subtle strengths of warm and cool values is of the utmost importance in painting a good watercolor.

When a touch of burnt sienna is added, a wash of lampblack takes on warmth. If you make a small sketch, using this warm gray and a basic wash of lampblack, you will find that the latter will appear to have cooled considerably. Add a little indigo to the lampblack wash, and its temperature will drop even more when it is painted beside the warm gray. These two grays may have exactly the same value, but temperature alone will determine their true character.

To obtain a warmer gray, you may prefer mixing your own from cobalt, phthalo blue, red, and yellow. I don't think it makes much difference how you mix your grays, unless you wish a gray to precipitate and create a granulated texture; in that case, use ultramarine, light red, and a touch of yellow ochre.

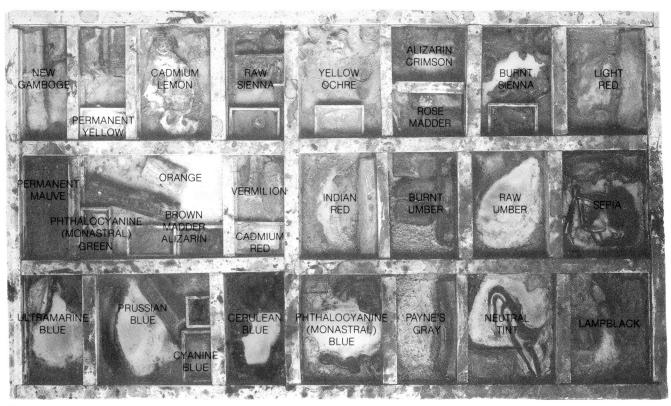

These are the colors on my own palette, which is shown on pages 38-39

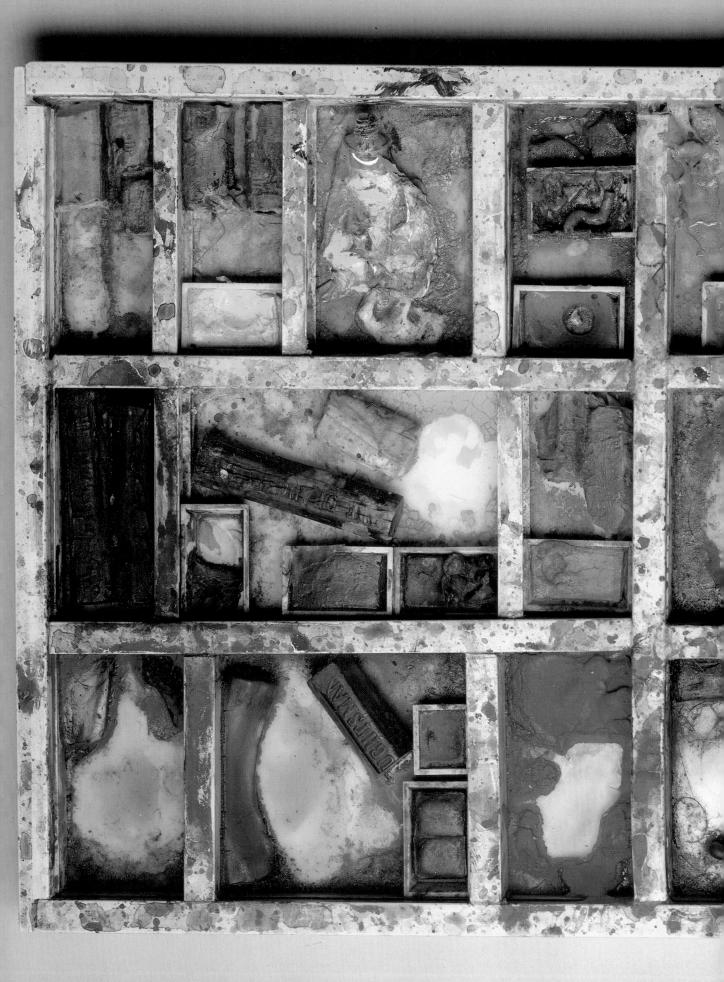

Capturing Atmosphere and Mood

In Part One, I showed some basic techniques for achieving realistic and impressive sky formations. The following eight demonstrations show you how I use these techniques in large paintings, as well as how I have learned to handle value and color through my own experiments over the years. There are details taken from different stages in some of the demonstrations so you can scrutinize the character of individual washes and also the brushwork. I urge you to study these details and each stage of the demonstrations, and work out for yourself how I painted so that you become really familiar with the characteristics of watercolor.

The aim of these demonstrations is to show not only painting technique but also how I think about and plan each painting. Most of the scenes in these demonstrations are attractive subjects in themselves, but it is the interpretation and treatment of them that is all-important.

Before you begin a painting, always try to work out your priorities. By this I mean stop and consider exactly what it is that is appealing about the subject and then decide what are the important parts of the scene that you want to become the focus of interest within your painting. Once you have determined this, then work out either in your mind or in loose pencil sketches exactly how you intend to treat the subject. It's not

necessary to build a plan like a military campaign, but it is important to have an absolutely clear idea of how you can bring the most appeal out of the subject in the scene you wish to paint. Will you rely on color, value, shapes, or textures? How much sky do you need to give your painting the right atmosphere? Do you wish to make it a very loose, relaxed piece of work, or do you want to give it a tighter, more formal rendering? Once you have worked out your priorities, the most important thing to remember while painting is, in my opinion, that it is important to make each statement in the most simple and direct manner that you can with watercolor. Always aim to use just enough pigment to make your interpretation. By using the medium economically. you have much less danger of overworking a painting.

When you think your painting is nearly finished, stop. If you tinker about with it too long you may feel in retrospect you have overworked and ruined what was a simple painting idea. Even though it may seem to you that I paint with great ease, speed, and just enough consideration, I still struggle a great deal with most paintings. And I still, even after all these years of painting, commit the cardinal sin of being overindulgent and finishing a painting with too much detail. Be warned!

Retaining Control in a Loose Treatment

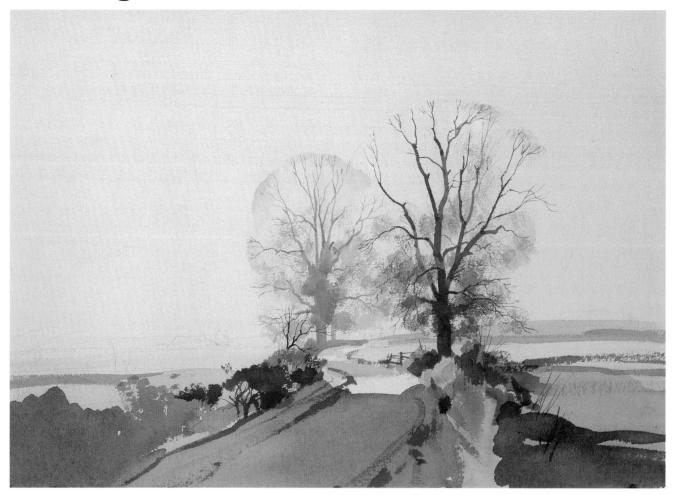

One of my great delights is wandering down a small lane on a clear, bright winter day. Although it is often quite cold, this slight discomfort is more than compensated for by strong light on a crisp landscape.

When painting a scene like this, I aim for a broad lighting effect and a general interpretation, rather than a realistic portrait. I disregard entirely such things as individual leaves or berries on the hedge. Instead I try to make the painting evoke a response to the scene by giving the *flavor* of the winter landscape.

In this painting, I made use of aerial perspective by painting the hedge in the foreground dark and then reducing the tonal strength of each object as it receded into the distance.

1. I began by indicating lightly in pencil the size and proportions of the trees in relation to the lane. Then I mixed a pale solution of neutral tint and constructed the trunk and main branches of the distant tree. I used the drybrush technique to indicate local masses of twigs and give an impression of a live but dormant winter tree, rather than a dead wooden skeleton. I used the same technique on the nearer tree, but this time I applied lampblack and burnt umber so that the tones would be stronger. The greatly enlarged detail on pages 44–45 shows the combination

of drybrush and direct line I used in painting the two trees.

To create the features in the foreground, I painted broad areas of dark tone; when these were dry, I applied a few quick drybrush strokes to define twigs, puddles, and tracks on the lane. I let all the paint dry hard and then applied a wash of burnt sienna and yellow ochre over the entire paper surface, except for the road just before the nearer tree.

This was a good start, as I had clearly established the range of tones and defined the composition with a minimum of detail.

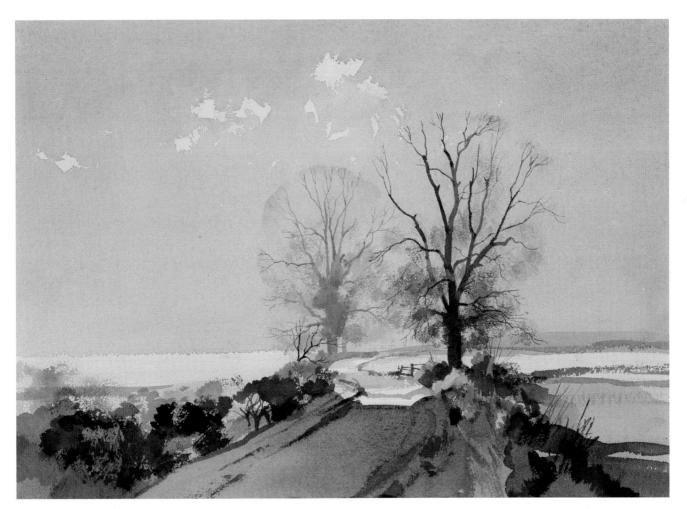

2. Now for some work on the sky. I laid a graduated wash of neutral tint and alizarin crimson over the whole sky, leaving a few hard-edged areas to form clouds. I added a little water while this wash was still wet to ease its strength toward the horizon.

I darkened the road in the foreground, leaving the wash to dry flat, rocking the board occasionally to encourage granulation and texture. I put more detail into the foliage beside the road.

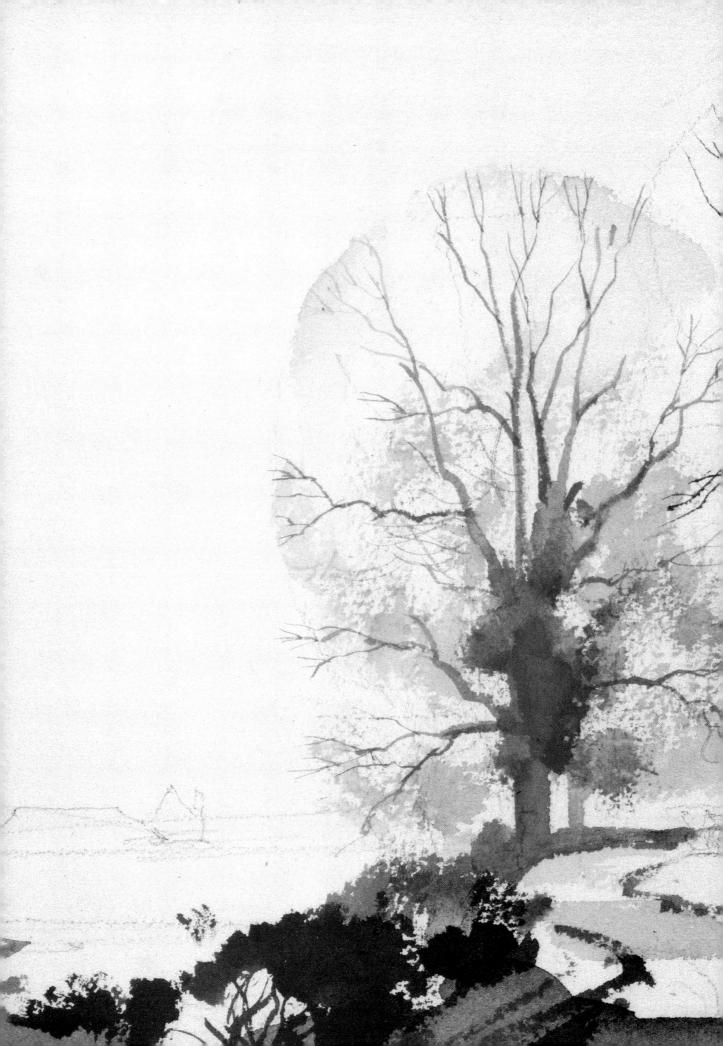

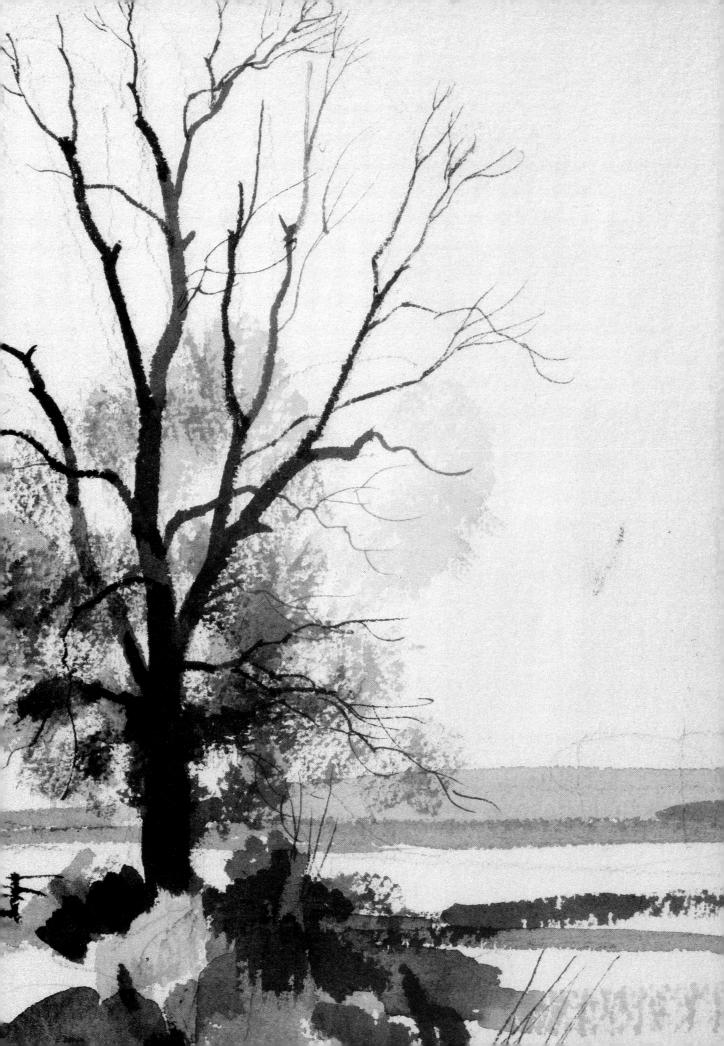

3. I completed both trees by painting in more twigs, drybrushing rough patches of color at the extremities of some branches, and finally, laying very fine washes over the entire leaf area of each tree, defining its shape and character.

I painted the shadow sides of the clouds with a pale solution of neutral tint and used a slightly richer mixture at the top of the painting for the darker cloud. With areas of dark tone at the top and bottom of the painting, interest automatically focuses on the middle and far distances—exactly as I had planned.

I used neutral tint to show the trees and hills beyond the distant tree, keeping it all very simple and plain. Finally I worked up the variety of dark tones and colors in the hedge and along the roadside, adding a few strokes of yellow ochre mixed with white for warmth in these foliage areas.

On reflection, I think I prefer the two main trees as they were in stage 2, where they were less powerful. I think they look overloaded in stage 3.

The detail above shows the subtle washes and drybrush with which I indicated the twigs and dead leaves.

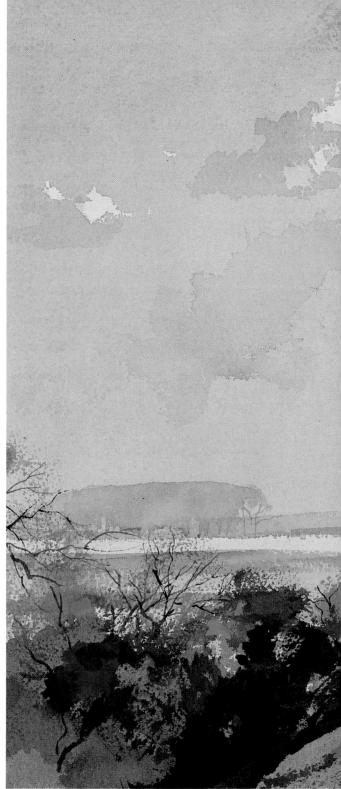

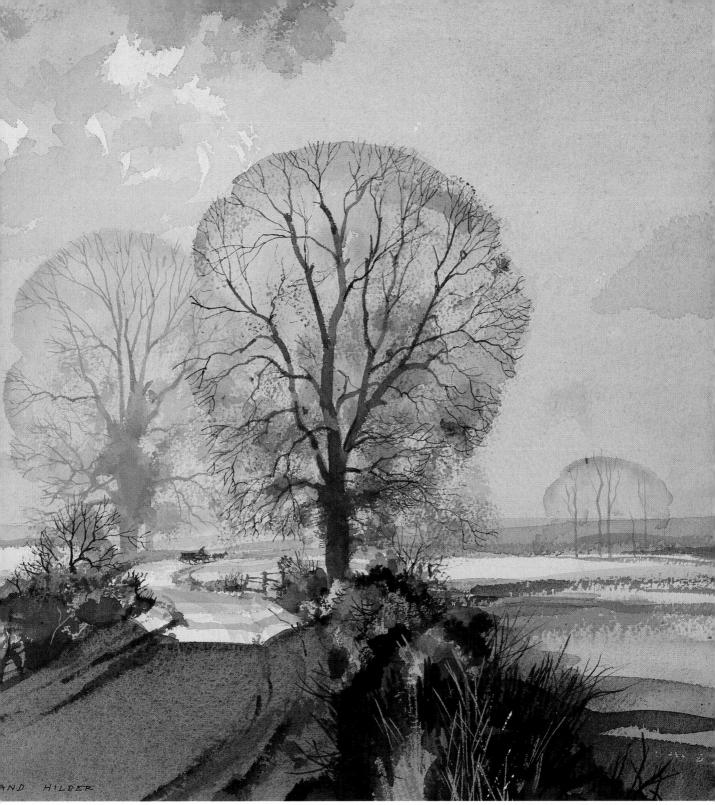

Tree Lane, 15" x 22" (38 x 56 cm)

Creating a Strong but Subtle Sky

This is one of my favorite kinds of scenes. I am often asked why I paint so many waterway and creek scenes when the tide is out. On reflection, the answer is obvious: at high water, I am busy sailing but, having anchored or more likely run aground in some remote and lonely creek, I can relax and enjoy the scene, making notes and sketches until the tide rises again. Sometimes, I just sit and listen to the constant sound of lapping water, the wind in the rigging, the cries of gulls, and quieter noises made by birds or insects. The watermen jokingly refer to my kind of sailing as "ditch crawling." Sometimes I leave the boat quietly aground on a mud bank or sandy bottom and head inland in the tiny dinghy which, having no mast, can proceed un-

der bridges and into delightful secret places.

This painting was the product of feelings evoked by contemplating numerous small sketch notes and water-colors done on location. But before reaching for the brush, I stopped and thought about what the picture was to be about and put the priorities in order. This study was to be about the sky, the land, and the water, in that order—and so the sky had to have detail, and the land and water had to play a secondary role. I decided to suggest the features of the banks simply so that their hard texture would contrast with the soft sky.

Basically, a complicated painting needs a simple sky, but a powerful sky must have a subordinate landscape or seascape below.

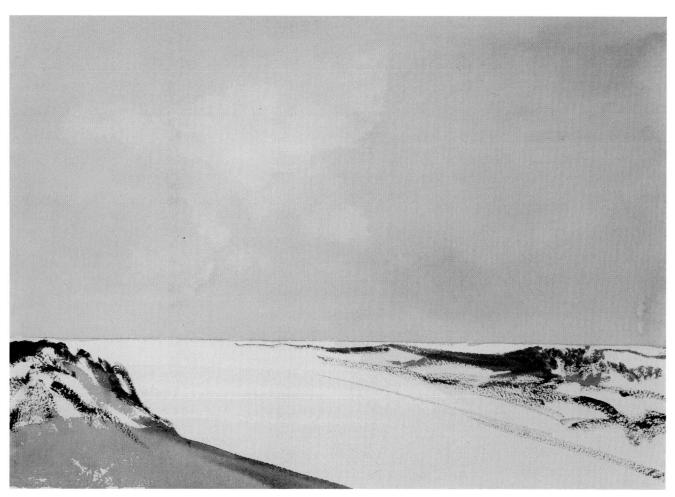

1. I began by making some simple pencil marks on the paper to establish an absolutely straight horizon. I mixed a basic wash of burnt and raw sienna and applied it across the whole sky and in the lower foreground, leaving the area near the horizon white. I let this first wash dry thoroughly and then applied another wash of the same two colors, making it a little darker on the righthand side. While this was still damp, I used some absorbent paper towel to blot out some of the pigment and create a central area of bright light. When this was dry, I added a blush of alizarin crimson, softening the edges with paper towel.

Now that the basic sky was established, I indicated the darkest areas in the foreground with deep sepia, contrasting them with the white areas and establishing the tonal extremities. A wash of the same sepia produced the area of mud in the nearest foreground.

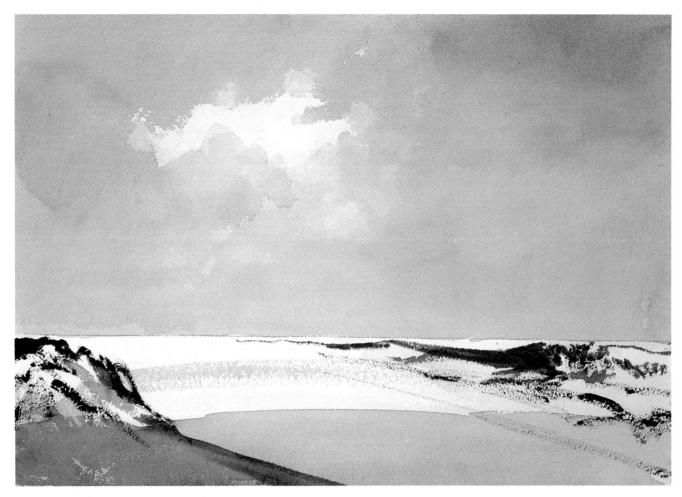

2. Now came the exciting part: attacking the sky shapes, tones, and colors. It is necessary to be bold to achieve a strong sky, but too strong a color ruins the whole effect and will send your cost of paper towels soaring, if you are lucky enough to retrieve the painting.

I added a wash of lampblack to the top of the picture, and as I worked down to the light patch in the sky, I introduced a touch of blue, leaving a hard edge around it in the center of the sky. While this wash was still wet, I fed in a little neutral tint so that the top right area of sky became darker and looked threatening. I laid more lampblack wash over the water in the inland creek area and drybrushed one stroke just below the horizon to establish textural extremes between the rippling water (cat's paw) and the soft sky.

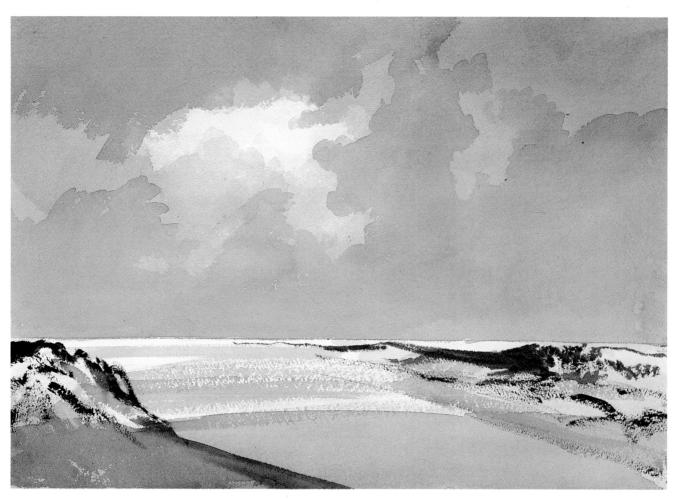

3. I let the washes dry thoroughly and then went back to work on the sky. I intensified the areas above and below the patch of light with another thin wash of lampblack, letting the edges dry hard to give powerful cloud shapes. I balanced the strength of the water with the sky by drybrushing in some diluted Payne's gray, leaving some areas white—especially along the horizon line.

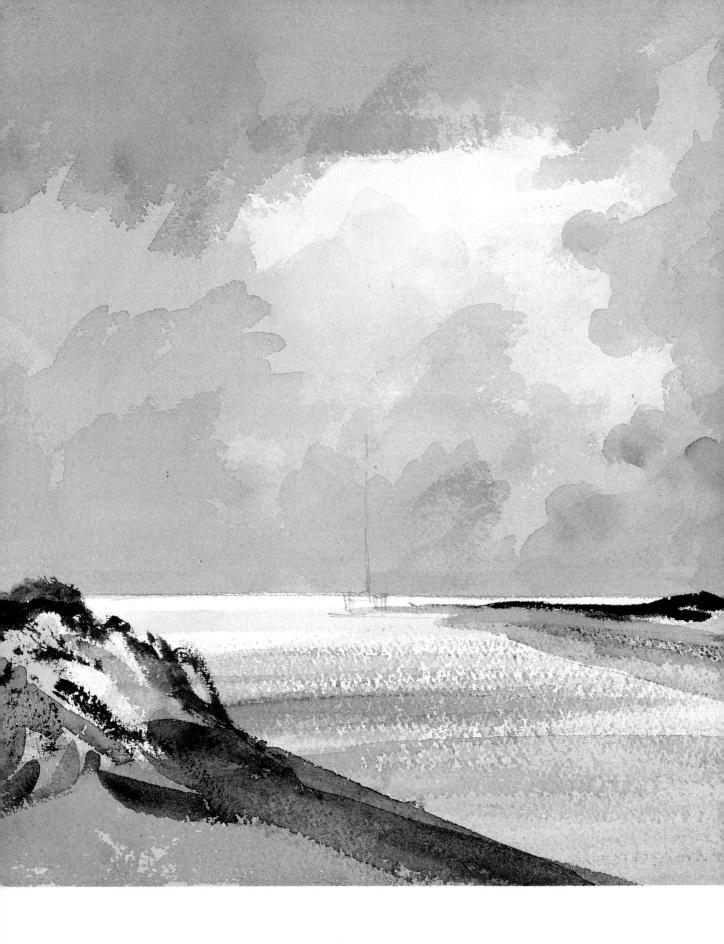

4. Next I did more work on the sky: I added deep-toned clouds in neutral tint on the right-hand side, and before they dried I fed more color into this sky area until I knew I had overdone it and the darks were too strong. I wet the area and set to work with the sponge and paper towel, lifting out some of the darker central parts of this mass until I felt there was a satisfactory tonal balance. Some of the darkest cloud edges remained, giving drama and adding shape to the cloud forms.

I worked sepia and burnt umber into the banks of the creek and further strengthened the water at the mouth of the creek with drybrush. Finally, I indicated the outline of the boat in the mud and let the whole painting dry off.

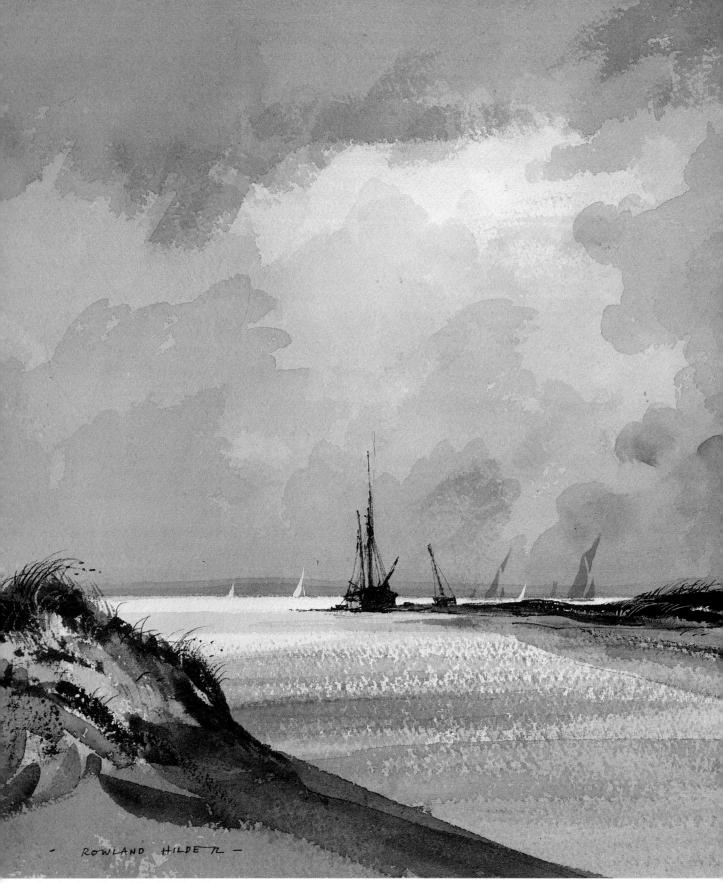

Creek at Low Water, 15" x 22" (38 x 56 cm)

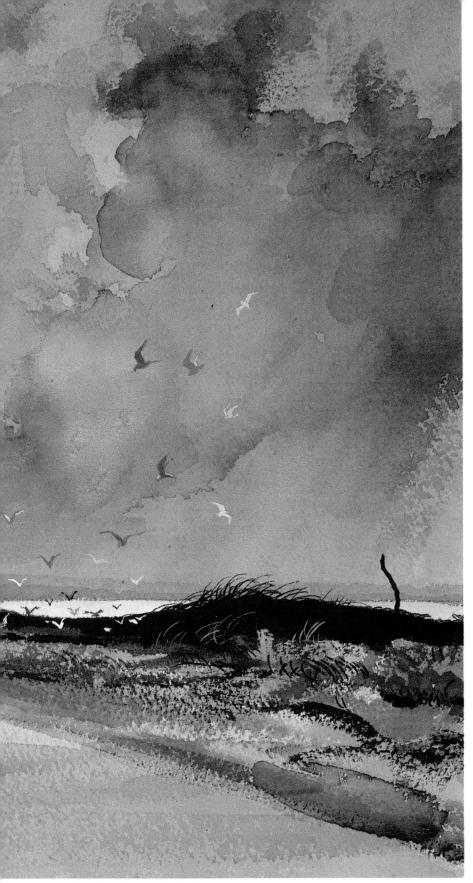

5. The painting was nearing completion now, and all that remained to be done was adding details and bringing up the brightest highlights. Just above the horizon, I added a line of neutral tint to suggest the distant landscape and a line of wash to create the ranges of hills. When this was dry, I trimmed the horizon with a razor blade to achieve the brightest possible sunlit edge. I painted in the dark boat with neutral tint and black, and then I put in the two large sailing craft with neutral tint and burnt sienna. The little white yachts were flicked in with gouache, and I added just a few grasses and the marker stick (used for navigating) on the right. I suggested just a few details on the banks of the creek; any more than this would have brought the visual interest forward and detracted from the sea and the strong sky. I added a few gulls with neutral tint and white gouache. I left the painting for a few days, during which time the paint hardened. I was dissatisfied with the position of some of the gulls and lifted out one or two and put in others until the balance was pleasing.

Balancing Areas of Bright Light

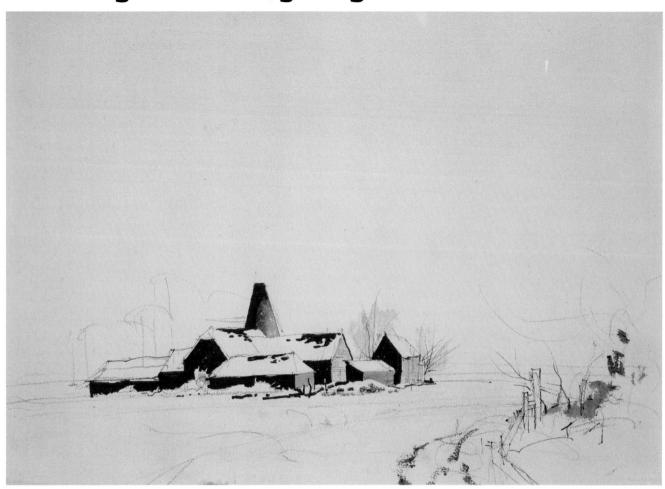

I saw this scene early one morning at a farm I know well. The snow had been thick but was beginning to melt, leaving dark patches on the barn roofs. The sun and snow combined to create a bright glare, and I was intrigued to see if I could capture the intensity of the day and balance the wide range of tones in watercolor.

I. I already possessed drawings of this farm, and so I worked out a composition, setting the buildings low on the paper to give full prominence to the sky. I used black waterproof ink for the wooden walls of the barns in shadow so that these parts would be absolutely stable and would not be affected by subsequent wash work. For once, I wanted the lightest tone to be virgin paper and the darkest tone to be jet black. The sky, which was a range of mid-tones, would become more interesting because of its more subtle tonal variation.

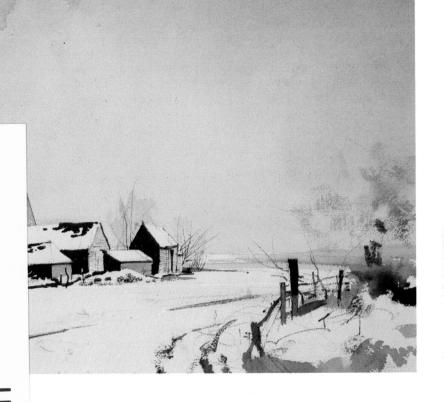

BUSINESS REPLY CARD

Postage will be paid by

1515 Broadway New York, New York 10036

Watson-Guptill Publications

Permit No. 46048

FIRST CLASS

NEW YORK, N.Y.

NO POSTAGE NECESSARY IF MAILED IN THE

UNITED STATES

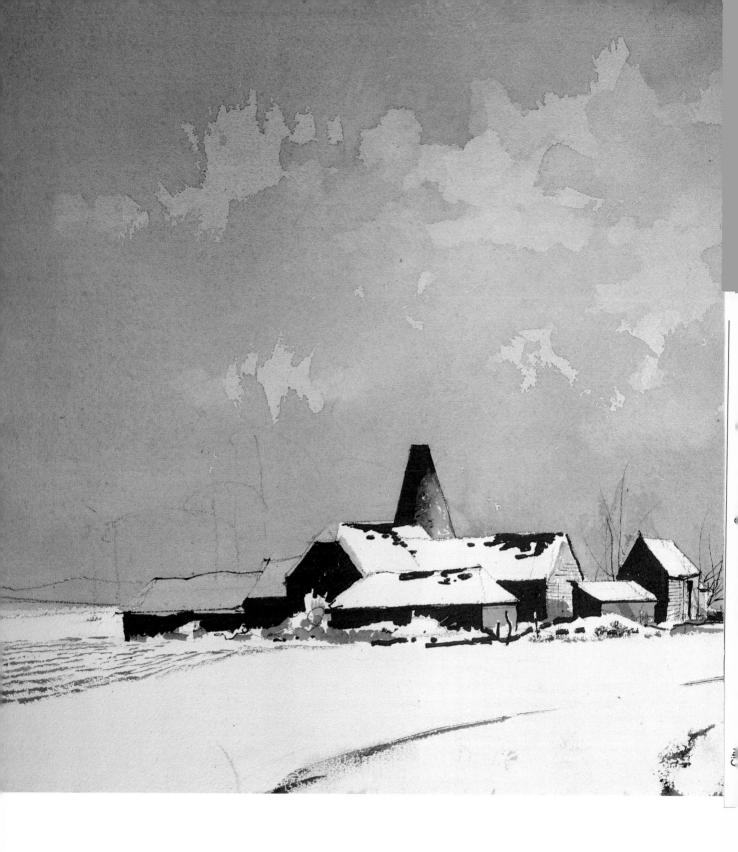

3. I wanted to try to paint the sky's main features in as few washes as possible, to prevent the risk of turning it muddy. I made up a muted blue with ultramarine and light red and worked from the top of the paper downward, leaving light areas for clouds and increasing the proportion of light red and water as I neared the horizon. While this was still wet, I used some paper towel to lift out some of the hard edges and create variations among the masses of clouds.

For relief, I mixed a little alizarin crimson and ultramarine and touched in the snow in shadow on the roofs and the foliage on the right.

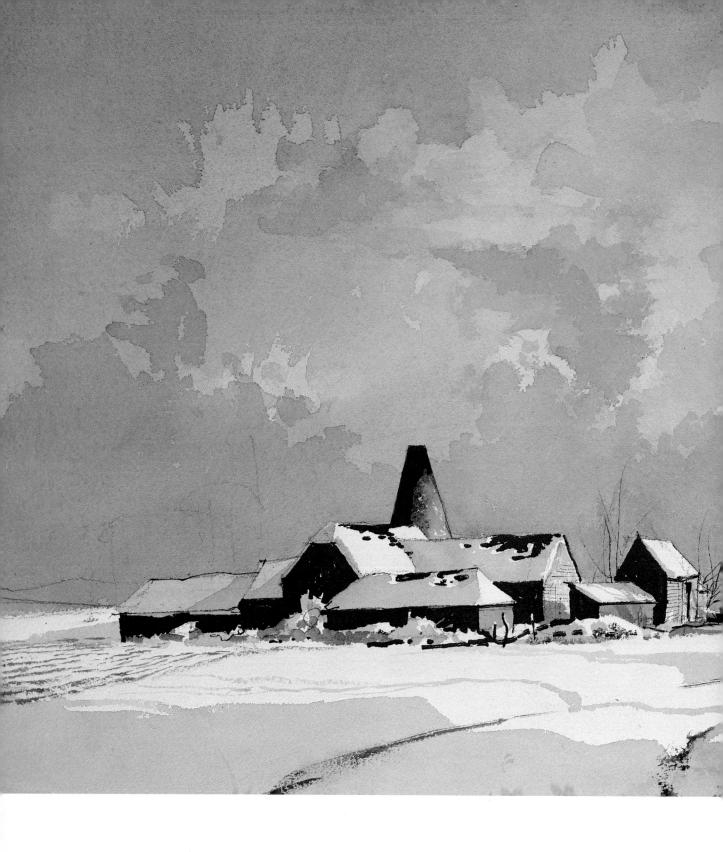

4. To create the menacing clouds stemming from the horizon, I mixed ultramarine and light red with a touch of yellow ochre to make a blue-gray that was cooler than the previous warm red wash. I left hard edges to these clouds, achieving a balance with the upper area of blue sky.

A weak wash of neutral tint for the roof shadows, shown close up in the detail below, echoed the blue in the upper sky and in the extreme foreground. I was satisfied with the resulting balance between warm and cool colors and the apposition of dark and light tones; the painting now had variety and harmony.

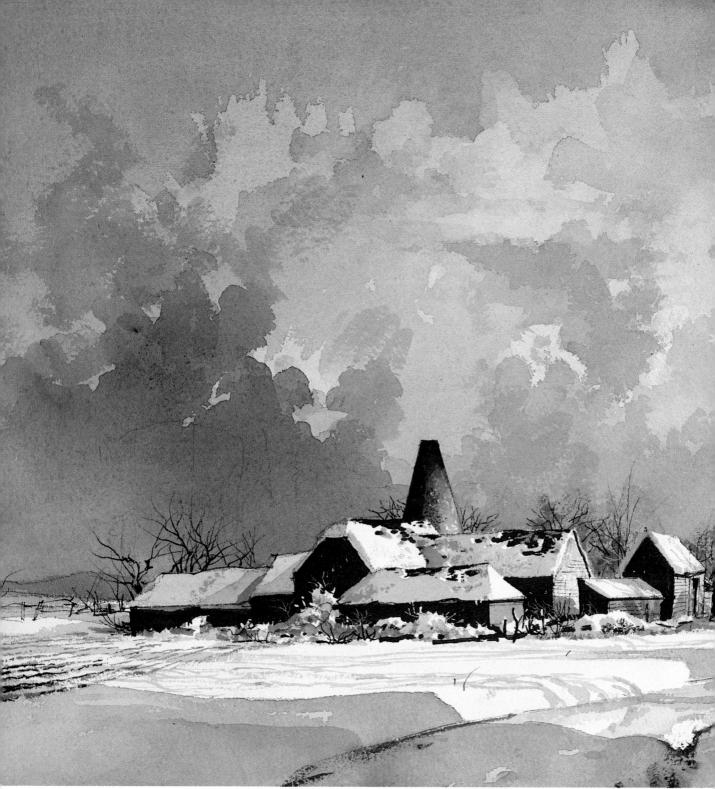

Snow in Morning Sun, 15" \times 22" (38 \times 56 cm)

5. The dark area of cloud behind the farm was too even along the entire horizon, and so I laid another wash of ultramarine and light red with a touch of yellow ochre directly behind the buildings, graduating it away to the left. A range of distant hills created a good illusion of recession.

I added detail and weight to the snow shadows in the foreground with ultramarine and light red, and put tiny details into the snow on the roofs. Then I spent some time defining the trees and bushes on the right and behind the buildings, taking care not to get carried away and make them too prominent. The farmer and horse gave the scene a touch of life. I stopped there—the picture suddenly verged on being overcomplicated, and I decided it was quite effective as it was.

Looking back, I find it interesting to note that by darkening the sky in stage 4, I made the snow appear brighter. There is no white at all in the sky—the snow is the lightest tone and must appear to be so. The gray sky heightens the brilliance of the snowy rooftops, shown in the close-up below.

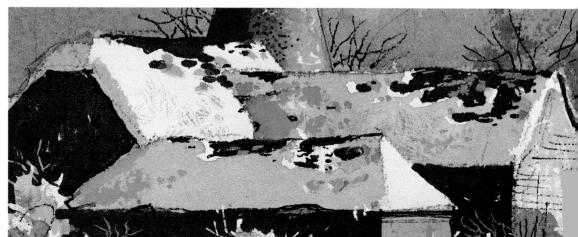

Retaining Impact in a Quiet Painting

An old seaman once told me that on a calm summer day, he could remember seeing hundreds of sailing craft becalmed about the Thames and Medway estuaries. I can just remember seeing scenes like this one when I was a lad, and it must have been a common sight for the old traditional marine painters. How I envy them their subject matter now!

The information for details of the ships and their rigging was taken partly from memory and partly from a personal knowledge of sailing craft gleaned from ship models, old prints, and paintings. I would in fact be flattered if someone mistook my picture for an old painting!

There appears to be more drawing in this painting than there actually is. Most of the work was in the careful overlaying of fine washes, which created a glassy sea and a strong but sensitive sky. 1. As this painting was not a portrait, it was not desperately important to be accurate and show great detail. This did not mean that I had license to invent. I have always had a passion for sailing craft, and these ships are all quite accurate reconstructions. My main aim in this painting was to create an interesting composition and enhance the mood instilled in the scene by the sailing vessels.

I made a freehand enlargement of my best compositional drawing directly on the watercolor paper. I kept it extremely simple: I wanted the washes to do the work. I mixed a wash of raw sienna, added a little burnt sienna to it, and laid it across the entire working surface, except for one sail. I eased out the sky just left of center, and while the wash was still wet, I intensified the sky just to the right of center with a little extra burnt sienna.

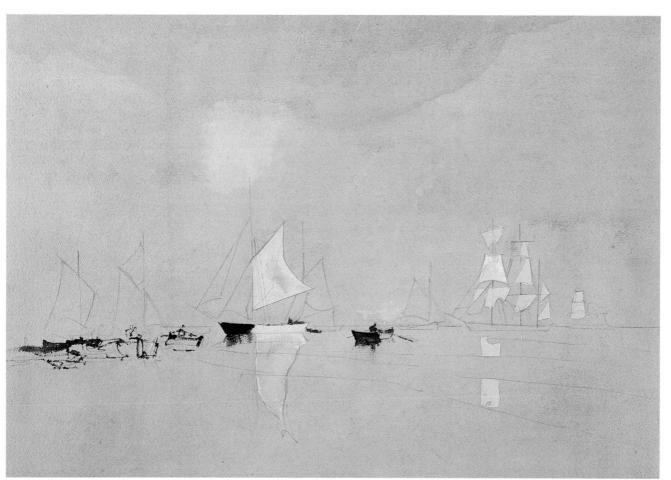

2. When the basic wash of raw and burnt sienna was bone dry, I mixed a flat wash of cobalt and phthalo blue and applied it generously, leaving hard edges around the sails. I fed some extra color into the top of the sky while it was still damp. This produced a hard edge that I could have done without, but I decided to let it remain and see what happened. When these blues were dry, I put in the blacks with quite thick paint and very little water. At this stage, I left the painting to go and do something else. When I next looked at it, it seemed to have turned very cold; the blacks and blues were dominant. I added a touch of raw sienna to warm the sails, and this brought the painting back to life.

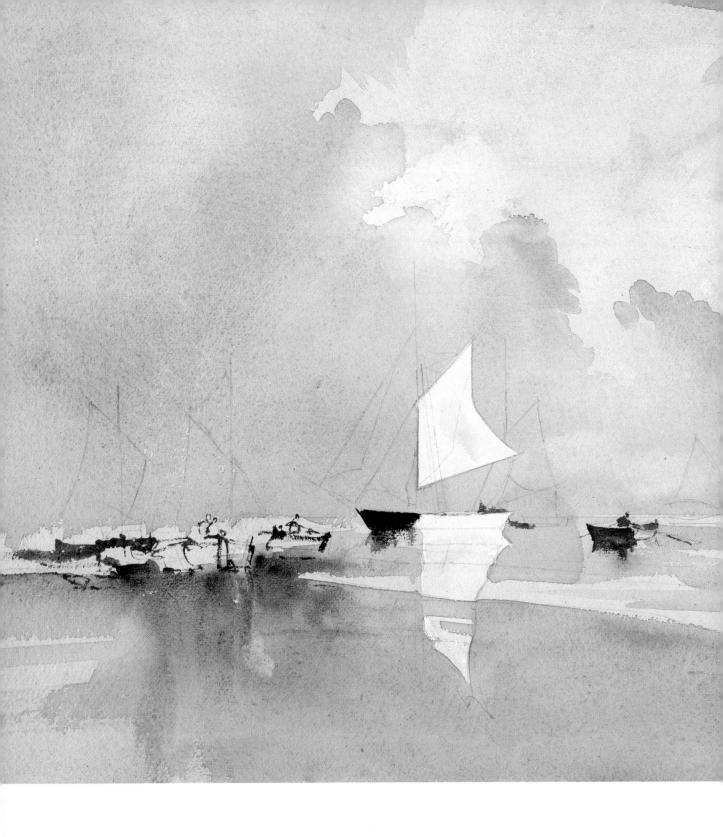

3. Even though the scene was calm, it was essential not to let all the washes dry even and smooth, giving a flat, boring result. I mixed a gray from cobalt blue, ultramarine, and light red and laid it into the sky. Suddenly, the picture had turned cold again, and so I added more light red to the sky passages while they were still wet, restoring the balance. I tilted the whole board back and forth, and then laid it flat to dry. This technique produced the maximum amount of paint granulation and gave texture to the clouds. I was afraid that the hard edges in the sky would look too regular, and so just above the figure in the rowing boat, I dabbed away some of the paint to produce an area of soft light.

I laid the same wash into the sea area, but while it was still wet, I added some lampblack below the boats on the left and tilted the board so that the wash flowed down the paper, simulating reflections. This created a pleasing contrast to the drybrushed figures and boats, as can be seen in the enlarged detail below.

I began to get excited, for I had restored the warm color to the painting, and the sea in particular looked as calm as I had intended. I moved on quickly.

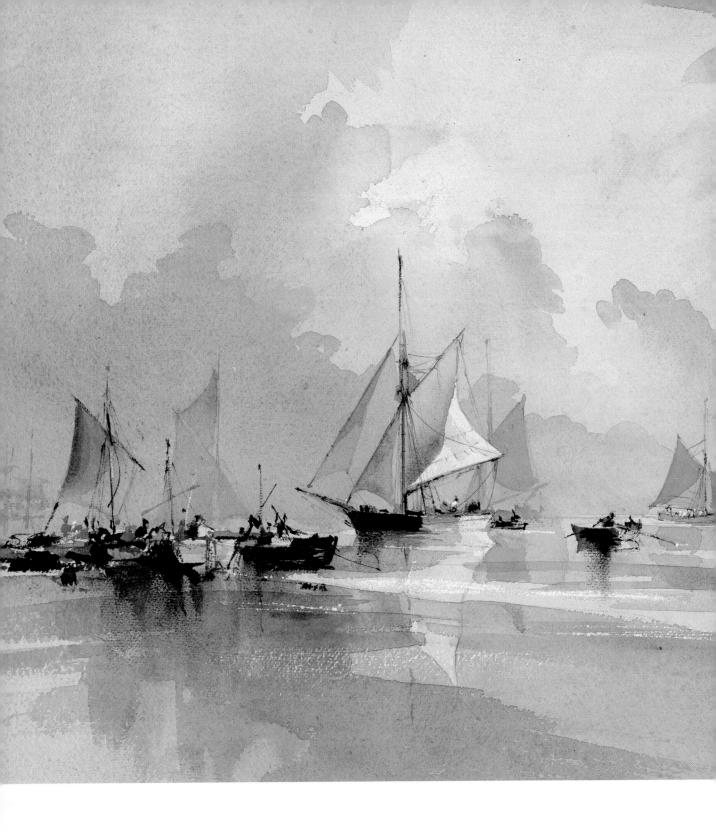

4. The picture was well on the way to being complete. I wished to emphasize contrast in the sky, and so I added a granulated wash to the top right-hand corner; then, mixing up a wash of cobalt, ultramarine, and light red, I laid it boldly across the sky and sea on the left. I used some drybrush on the sea to produce slight ripples and scratched in some highlights with a razor blade. It seemed to work.

Now for the ships. I wanted to bring up the warm tones and so I used raw and burnt umber, raw sienna, lamp-black, and sepia. I created an impression of figures, oars, and rigging on the group of craft on the left to balance the activity there with the soft, open areas of sail cloth above and the sea beneath (see detail below).

I stood back. Fine! I should have left it there.

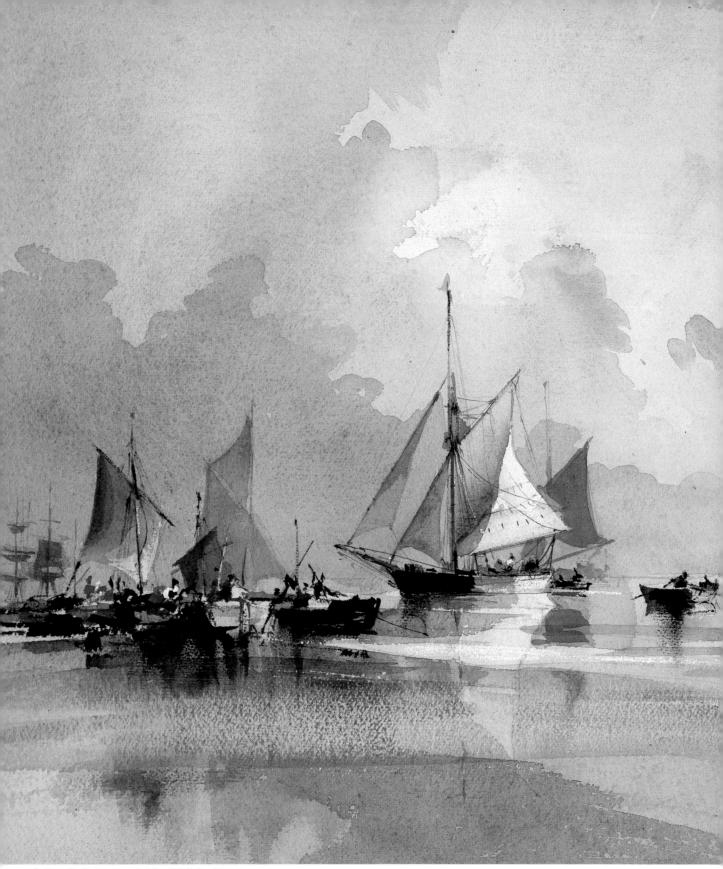

Sailing Craft Becalmed, 15" x 22" (38 x 56 cm)

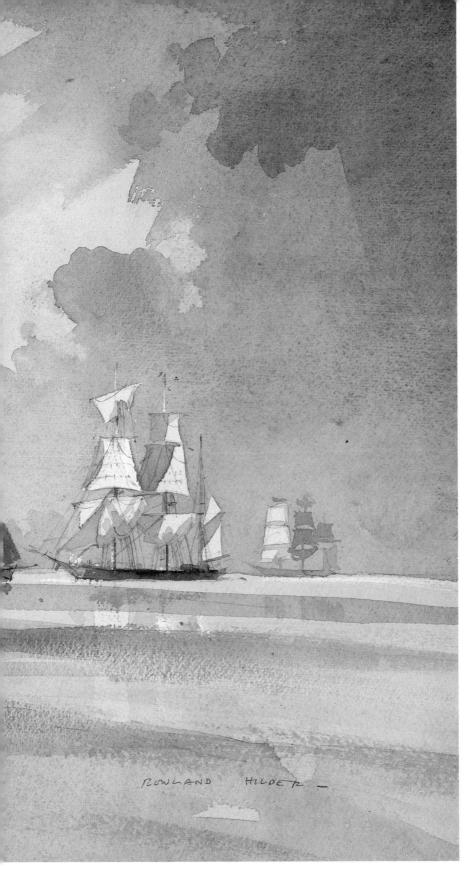

5. After I had decided that this painting was finished, I looked it over a few times and began to wonder if the water was quite convincing. Should I try to correct or modify it? Maybe some of the edges of tone on the water were too hard, or overly heavy? I wasn't quite certain. It has been said many times that a watercolor is best left alone when second thoughts occur, and that paintings are often completely ruined by overworking. However, I went ahead and decided to risk making certain changes.

I set about reducing the tone of the water by washing out areas, hoping to create the impression of gentle ripples on the surface. I used a large water-color brush loaded with clean water, pulled it sharply across the surface, and then washed away the paint I had loosened.

I also felt uncomfortable about the height of the boom on the central fishing boat and decided to extend the area of sail downward, to lower the boom. Using white waterproof casein, I painted out the area for the additional piece of sail, let it dry, and then glazed over the area with raw sienna. A successful piece of patchwork.

Finally, I strengthened some of the tones of the sails and added another sail to the foreground group of craft. I declared the picture finished at last.

Later, when I compared the large color transparencies of each stage of this painting, I was not at all sure that the changes made in stage 5 had improved the picture. It had lost some of the simple charm produced by economic painting statements in stage 4. Indeed, I even wonder if I should have left the water as it was in stage 3.

Creating Mood

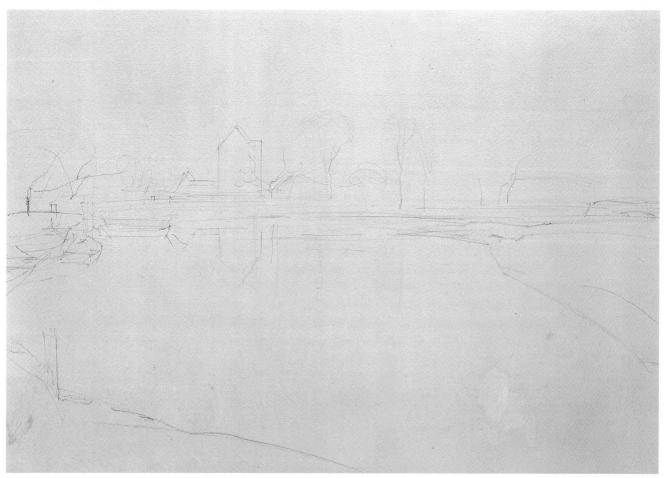

How do you convey mood in a land-scape? In essence, mood or atmosphere is stronger in a painting where there is no definite focal center demanding attention or scrutiny of itself. Mood is more apparent when the light is low, soft, or diffused; when shapes within the scene are blurred or slightly out of focus; and when the values are deep and dark and tonal counterchange is gradual.

My interest in this particular subject began many years ago, when I was commissioned to illustrate Mary Webb's *Precious Bane*. Because I was hired in the autumn and the illustrations were required by spring, I worked on location in Shropshire throughout the winter. The experience of painting outside during the winter months initiated me to the beauties of the winter landscape. On reflection, I discovered that this season in the year had not been recorded by the great masters of the English landscape.

Mary Webb's description of Sarn Mere conveyed a mood of tranquility, and I aimed to convey this mood rather than make a striking portrait of a specific place.

In this particular painting, I tried to paint as little as possible on the paper, keeping the objects in the scene vague and thinly described. Thus, the most prominent features of the finished painting turned out to be the light and the weather, which together conveyed a feeling, rather than described a scene.

1. Although I wanted a loose treatment for this subject, I took care with the basic freehand drawing, making sure the uprights were vertical. I used a T square to check the alignment of the mill reflections in the water and then laid a wash of cadmium lemon vellow across the whole surface area. The source of light was just outside the picture, but its reflection was in the lower center of the water. I used a small piece of paper towel to ease out the center of this reflection and then dabbed lightly at the top right of the picture to infer an area of slightly brighter light. I let the wash dry hard.

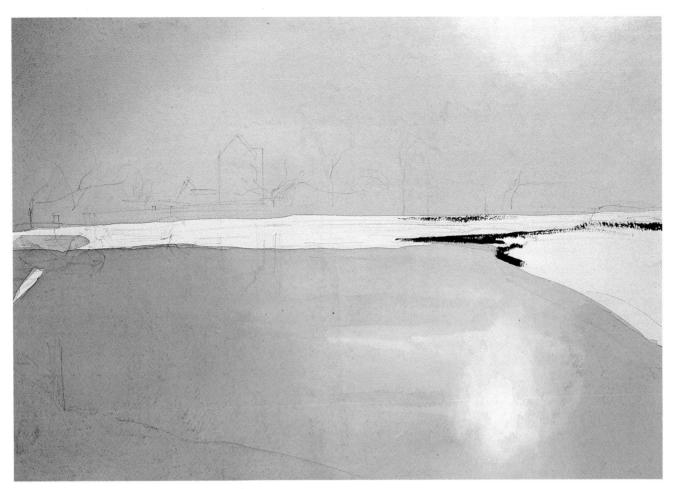

2. Now for some tricky wash work. I made up a thin mix of neutral tint and applied it to the painting, graduating it in strength from dark on the left to pale on the right. I eased out a larger circle for the reflected light in the water, dabbing with a piece of paper towel and leaving some sharp edges in this area to break the evenness of the reflected sky. It was important that the first wash of cadmium lemon was completely dry for this operation, as any of this agitation could have disturbed the evenness of the first layer of pigment.

As the wash of neutral tint dried, I drybrushed some extra strokes into the water to make dark patches on the almost still surface. It is these tiny subtle changes of tone that produce interest and variety within the dark, moody color. In the middle of the even wash, I introduced a sharp counterchange of tone by leaving a jagged spike of light on the extreme left of the painting. In apposition to this, I put in some stark, deep sepia on the right to establish the darkest tones. So far, so good.

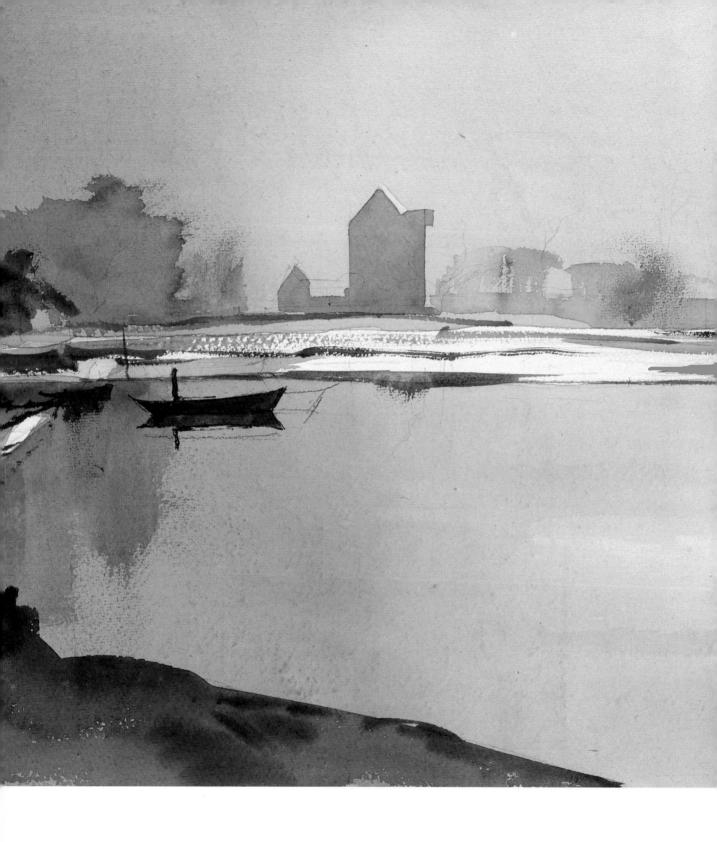

3. Before adding another wash, I left the painting to dry overnight, as I wanted the first few washes to harden. In the morning, I began work by laying another wash of neutral tint over the previous one. I created a larger aurora around the patch of reflected light, leaving the edge of the wash quite coarse.

Now for some rich tones. I marked out the banks of the pool with thick, fast strokes of sepia and used lampblack for the features on the extreme left. Then I mixed a strong wash of these two dark colors and put in the bank in the foregound, leaving the paint to create the form of the land by itself. I indicated the scrubby vegetation on the far right (shown enlarged above) with a combination of direct line and drybrush.

Having established credible recession from foreground to middle distance. I laid in the mill and trees with two tones of neutral tint, leaving a streak of light on the mill roof to give depth to the shape of the building. The reflections in the water below the boat were drybrushed to give a slight ripple to the surface. So far, the colors ranged from cold to cool, and so I made the painting warmer by dashing streaks of burnt umber across the center of the painting. Note that this color is rich on the edges of the painting but weak in the center, which enhances the effect of distance I wished to create. The addition of the boat further developed this recession.

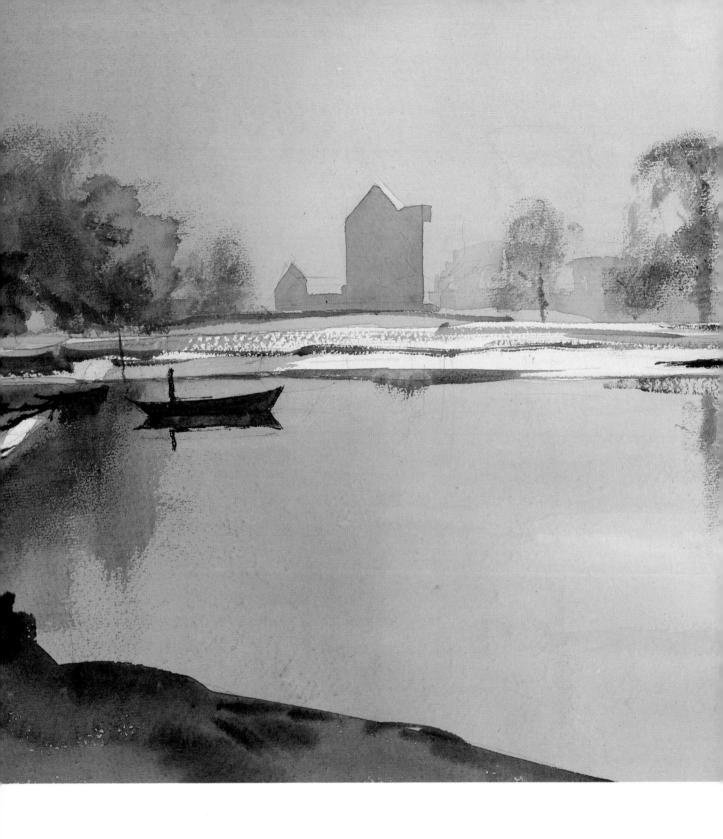

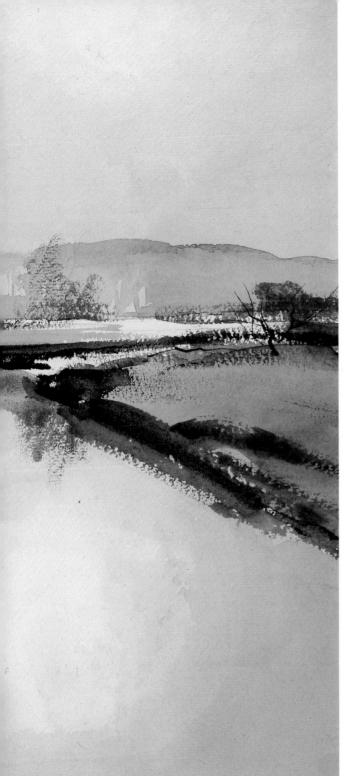

4. Now that the basic features were established, I turned to the textures of the land and foliage, dabbing in a raw umber wash for the trees and bank on the right. When this color was dry, I scrubbed in sepia, taking maximum advantage of the rough surface of the paper to create the broken texture among the tree branches and their reflections in the water. I strengthened the reflections on the left, shown in the detail above, the same way. Clarifying these forms gave detail and character to them, and suddenly, the painting seemed almost complete. The strength of mood was extremely powerful, and I could see that there was little left to do to finish this picture.

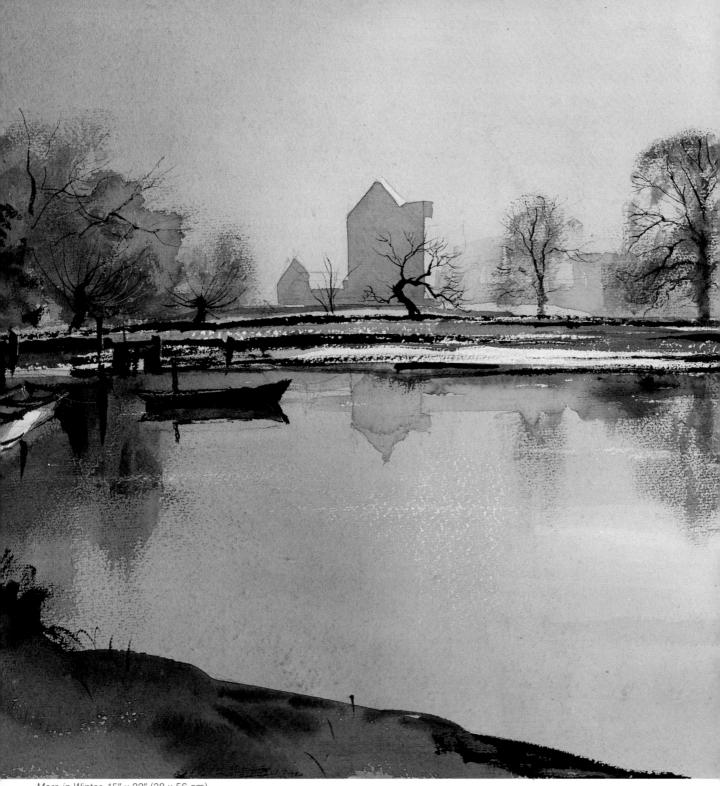

Mere in Winter, 15" x 22" (38 x 56 cm)

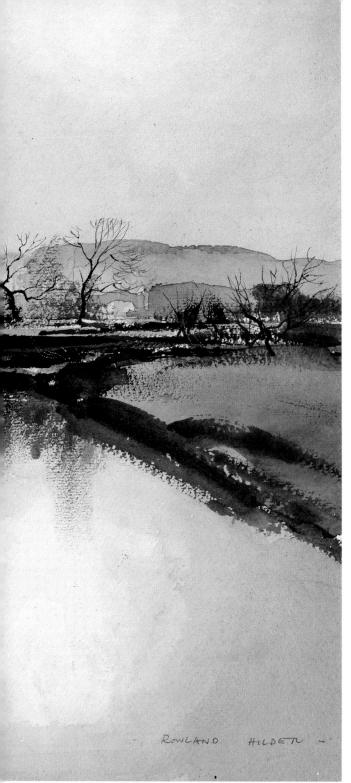

5. Among the dark, deep, somber tones the muted light seemed to pervade the picture. All that remained to be done was to tidy up and confirm the features of the main subjects. I used a fine brush with lampblack and deep sepia to define the jetty on the left, tree trunks and branches in the middle distance, and just a few silhouetted grasses in the foreground. The greater definition and darker value of the mid-distance trees, shown in the detail above, helped to create a good recession. With a razor blade I scratched in the highlights on the water, the willow branches on the left, and ropes and the rim around the top of the boat. That was just enough detail, and so I stopped right there.

On studying the finished painting, I was particularly pleased with the foreground because it is so sparse. I had resisted the temptation to overload the nearest bank with detail, and this economy allows the interest to recede into the distance.

Capturing Movement

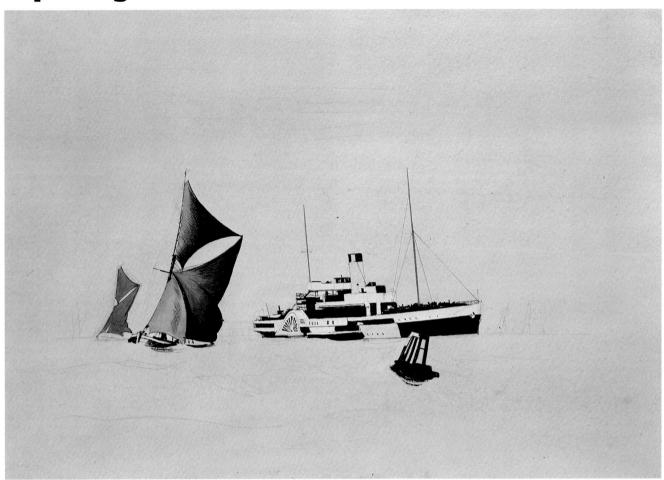

I made this painting for a business client who requested a series of paintings evoking memories of bygone days. This old paddleboat, the *Royal Eagle*, used to steam up and down the river when I was a child, and I was lucky enough to travel on board for a day excursion now and again. On such trips, I saw many large ships in full sail, the most numerous of which were the wonderful craft with deep red-brown sails, plying up and down the river with the tide.

I composed this painting from

memory and chose to depict the old paddle steamer in a following wind, punching the tide and sending back great rolls of spray and surf. I planned to show her overtaking the sailing craft running before a fresh breeze. The wind traveled faster than the paddle steamer, fanning forward the smoke from its stack and creating intriguing shapes in the sky ahead of the vessel. I decided that the sky should be active, but not overwhelming; with a clear picture in my mind, I set to work to recreate the scene in watercolor.

1. I had one engraving of the *Royal Eagle* and I made a careful drawing, altering the angle so that the features of the boat were exactly right. I scaled up the drawing, made a tracing, transferred it to the watercolor paper, and then blocked in the black parts with india ink, using a counterchange pattern of black against white and vice versa. This is best illustrated by the buoy, which is white against the hull of the boat but black against the sea. This counterchange heightens contrast and has the effect of creating really sharp focus on the paddle steamer. I used a

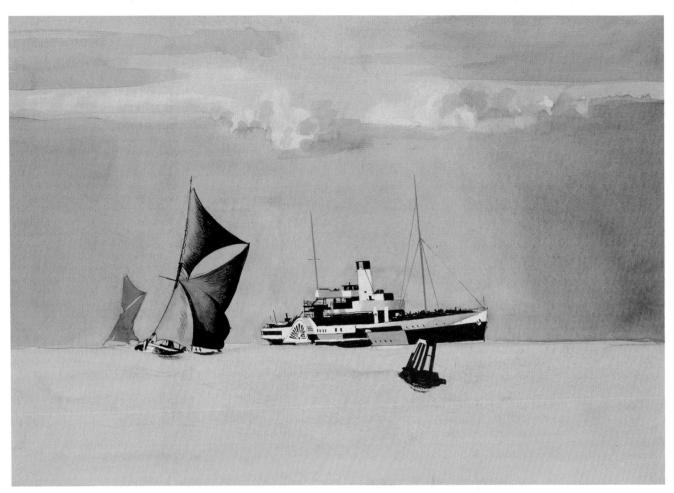

fine-tipped pen to draw the rigging.

I put in the largest vessel with india ink and indicated the others in pencil. I checked the horizon to make sure it was absolutely level and then laid a primary wash of raw and burnt sienna over the entire picture, except for the white areas of the paddle steamer; this simply made them appear even brighter against the blacks.

I mixed lampblack and burnt umber in varying proportions for the ship sails, and when these were dry, developed their form with fine brushwork in india ink. A good start. 2. Next, I put in secondary washes to establish the tone and color of sky and sea. I used lampblack over most of the sky and the clouds, leaving carefully positioned patches of this color in juxtaposition to the basic wash of raw and burnt sienna. It took concentration to lay this wash around the clear-cut features of the paddleboat and sailing craft. I let it dry and took a rest.

Next I produced the sea with a faint wash of lampblack and viridian, which I let dry bone hard. Before applying a second wash over the section of sky below the light area, I painted around the ship and sailing craft. When the second wash was dry, I put in some streaks across the sky at the top of the painting and reinforced the shadow sides of the clouds.

Time for some work on the paddle steamer. I had already clearly defined the features of this ship, but now it needed clarification of form, and so I washed a small amount of lampblack over two side panels and defined shadows on the bows and decks with neutral tint. At this stage there was little hint of any movement in the painting; only the full sails implied any motion at all.

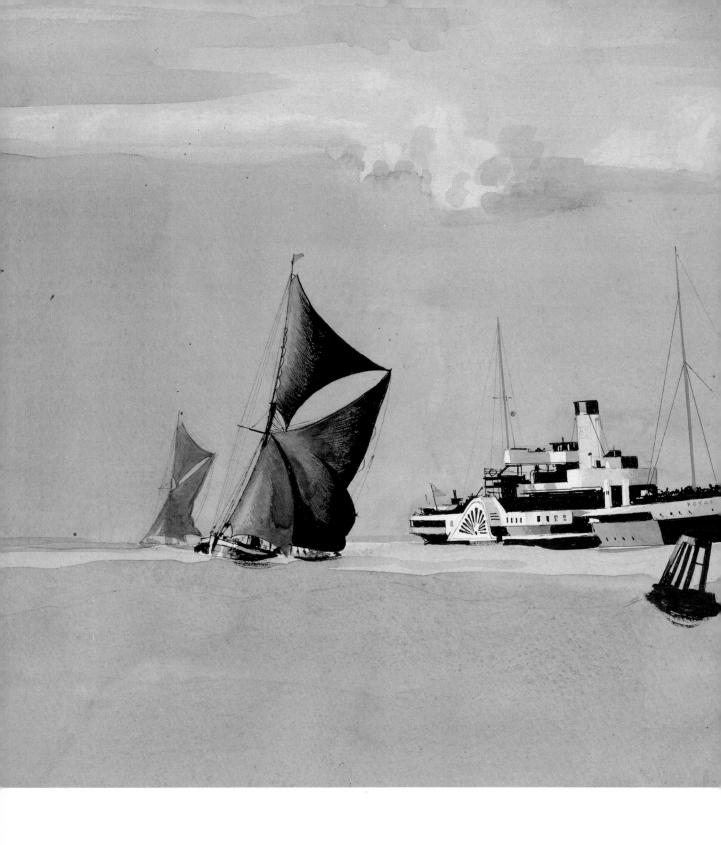

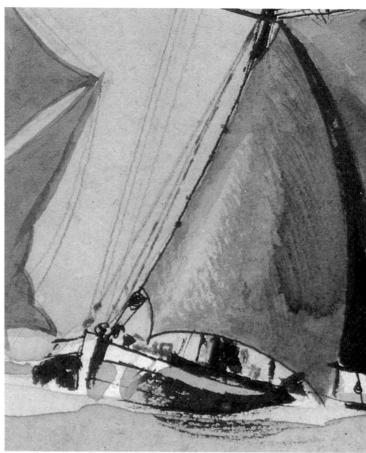

3. By this stage, I had established the shape and tones of the basic subjects at the center of this painting, as well as the surrounding sea and sky. I considered that most of the remaining work involved adding fine detail and tiny patches of color to the ships and buoy, in harmony with the overall strength of the sea and sky.

I laid a deeper wash of viridian and lampblack across the sea, but not right up to the horizon, thus creating the illusion of distance. I used burnt umber to give greater warmth and texture to the nearer vessel's sails (shown in the enlarged section above) and then added a touch of bright vermilion to the buoy, to the flag, and below the Plimsoll mark on the paddle steamer and on the tiny flag at the top of the sailing ship's mast. I darkened the stack with a little cadmium yellow and then added further recession by indicating the distant land and two sailing craft.

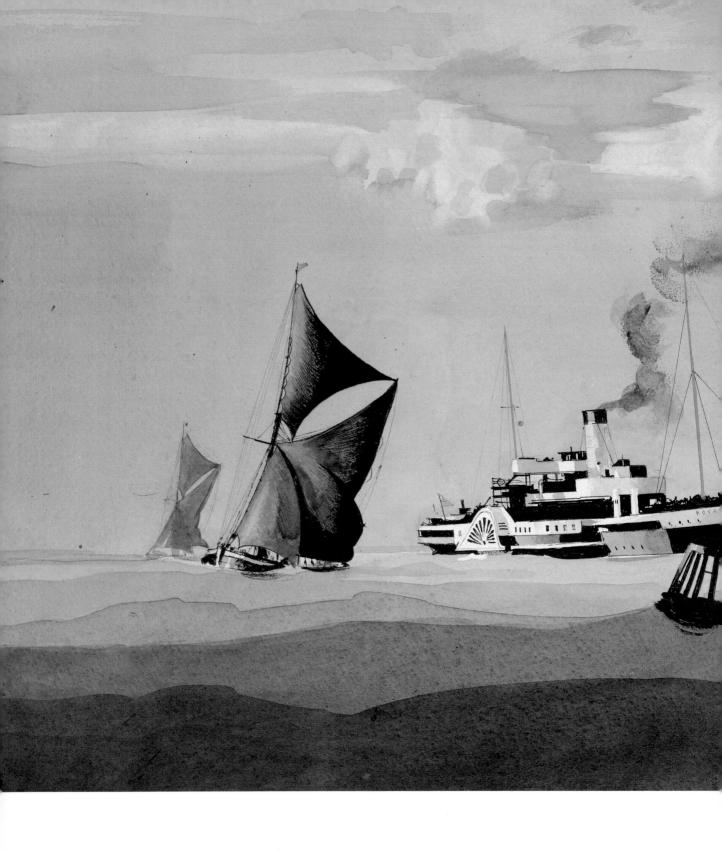

4. Time to inject some movement into the painting. I laid into the sky some hard-edged strokes of cobalt blue, creating the effect of high, streaky clouds. I dipped my finger into a mix of raw umber and black and worked up a blotchy trail from the stack, varying the density and shape of the color to simulate windblown smoke. Now that the smoke was visibly traveling faster than the paddle steamer, a strong sense of action was apparent. The detail shows how I used overlapping smudges of color to create the effect of transparent wisps of smoke.

It was necessary to create an agitated sea in keeping with the mood of the atmosphere above, and so I began laying successive washes of viridian mixed with lampblack, waiting for each one to dry before applying the next. The last of these washes was almost entirely lampblack, giving depth and luminosity to the sea in the foreground.

I stood back and, while surveying my work, dropped in a little shadow with raw sienna on the front of the stack.

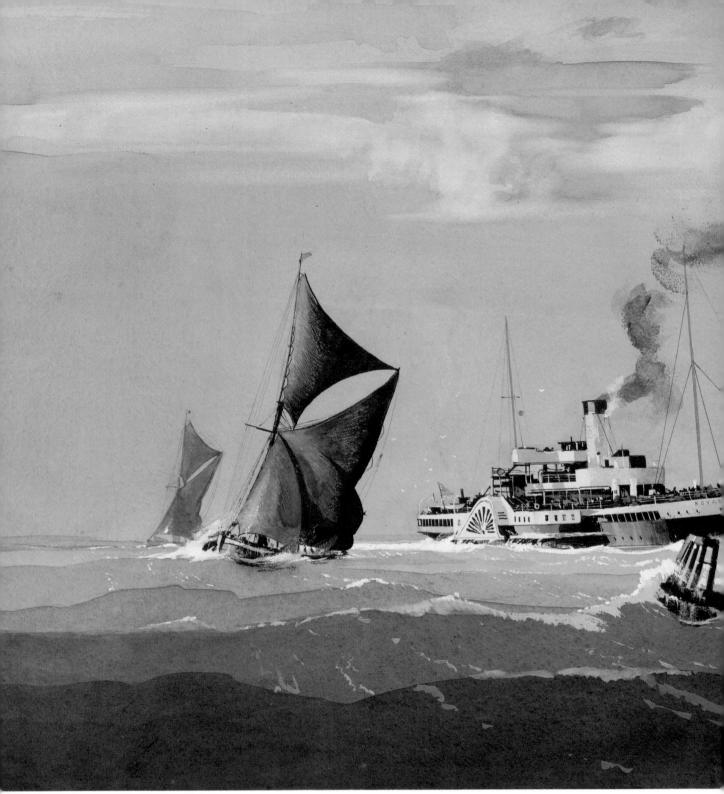

Paddle Steamer, 15" x 22" (38 x 56 cm)

5. I decided that the dark parts of the clouds directly below the areas of blue sky were too hard, and so I used a bristle oil-painting brush moistened with a little water to soften them and make their forms more nebulous. I blotted away the wet paint with paper towel. This worked well, and I was satisfied that the sky was now finished. I dabbed in the faintest signs of dispersing smoke near the top of the picture.

Finally, with the aid of a magnifying glass, I put in the highlights on the decks of the paddle steamer, using a rigger to apply the titanium white. The detail below shows how I used the same color to indicate the bow wave, wake, foam around the paddles, and the sea breaking onto the sailing craft. I added a little neutral tint to the titanium white in the foregorund to give shadow to this area. A few wheeling gulls behind the steamer completed this painting.

In retrospect, this painting worked out almost exactly as I planned. As a portrait, the paddle steamer has to be instantly recognizable, and by placing it dead center, I gave it the greatest interest. Normally, I eliminate detail from a subject, but here I've taken care to include it in the boat to give it strength. The paddle steamer is surrounded by quiet tones. The activity in the sky takes place high above the vessel, where it cannot compete for pride of place. Why is it there at all? Cover it over with your hand and the whole painting is dead.

Notice that the lightest tones in the clouds are at least "one and a half" shades darker than the whites on the ship. Though the clouds *appear* white, they are subordinate to the whites of the paddle steamer.

The sea *looks* active, yet there are no flicks of spray in the foreground that might detract from the ship—just a gentle swell indicated by light and dark tones.

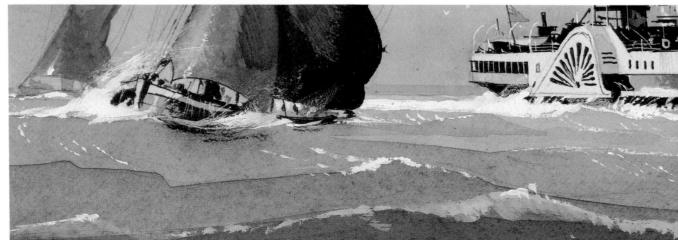

Varying the Tonal Pattern

This was a most difficult and complicated subject to render in watercolor. My aim was to produce a faithful and convincing portrait of a well-known, picturesque town while retaining, as far as possible, a feeling for the medium of watercolor. After much thought, I decided that the best way to achieve a successful compromise was to set the architectural features in a moving, atmospheric sky.

The danger with making a painting of a recognizable group of buildings is that the intense concern with the problem of making an authentic portrait can produce a lifeless picture overloaded with rigid, static detail.

With a subject like this one, you must face the fact that the chances are slim of painting an exciting, stylish water-color. Bearing this in mind, I decided to use whatever devices I could to keep this work alive. I planned to paint the bridge, church, and buildings with a degree of detail and offset them against a loosely painted, dynamic sky. I decided that the foreground areas of grass and water should be kept free of detail to simplify, as far as possible, an already overloaded subject.

1. In this demonstration and the next one, it was essential to make a really careful study in pencil before going anywhere near the watercolor paper. The town buildings and bridge appeared at first to be a complex mass of tones, shapes, and planes, and so making a preliminary study helped me to iron out all the compositional problems so that during the painting process I could be entirely concerned with light, tone, and color.

I made a tracing of the essential structure of the town and bridge, scaled it up, taped it to the paper stretched on the board, and traced down the image, using my own homemade tracing-down paper. I indicated the shapes of the

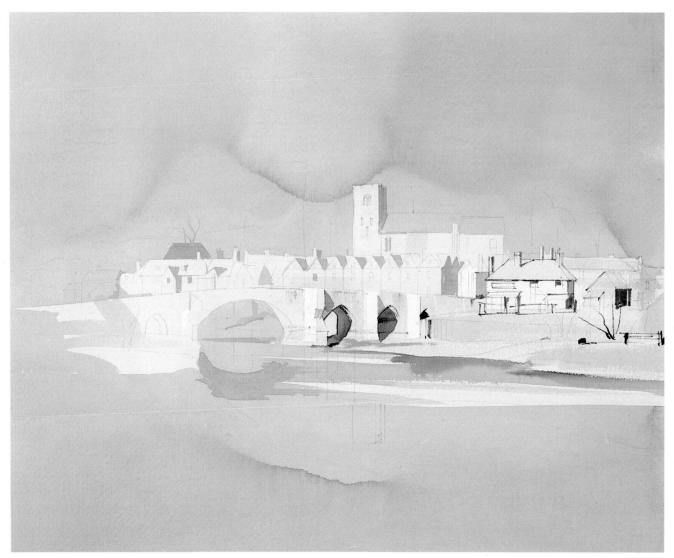

trees with lines showing their trunks and their height. I worked out which areas to leave white for the highlights and then laid a wash of burnt sienna with a touch of lampblack over the whole sheet of paper, using a large wash brush for the open areas and painting around the highlights with a small sable. When this was complete, I tilted the board slightly to ensure that the wash would dry evenly; I lifted out the excess water that collected at the foot of the painting. With a wash as large as this, there is a slight danger of making it too dark, thereby darkening the whole painting. However, as washes always dry out lighter, there is less danger than there seems when you are faced with the wet, dark paper.

2. I prepared a wash of lampblack and laid it over the upper and lower areas of the painting, using a large brush and taking great care along the tops of the buildings, the shore line, and under the central arch of the bridge. I let this wash dry thoroughly and then laid a second wash of the same color over the sky and foreground areas. Look what happened because I let this wash dry without tilting the board—great ugly, hard edges formed. I was sure I could handle the one in the foreground, but what about the unlikely-looking cloud directly above the church? There was nothing I could do but continue with the work, establish the darkest tones, and then, lay in the mid-tone range.

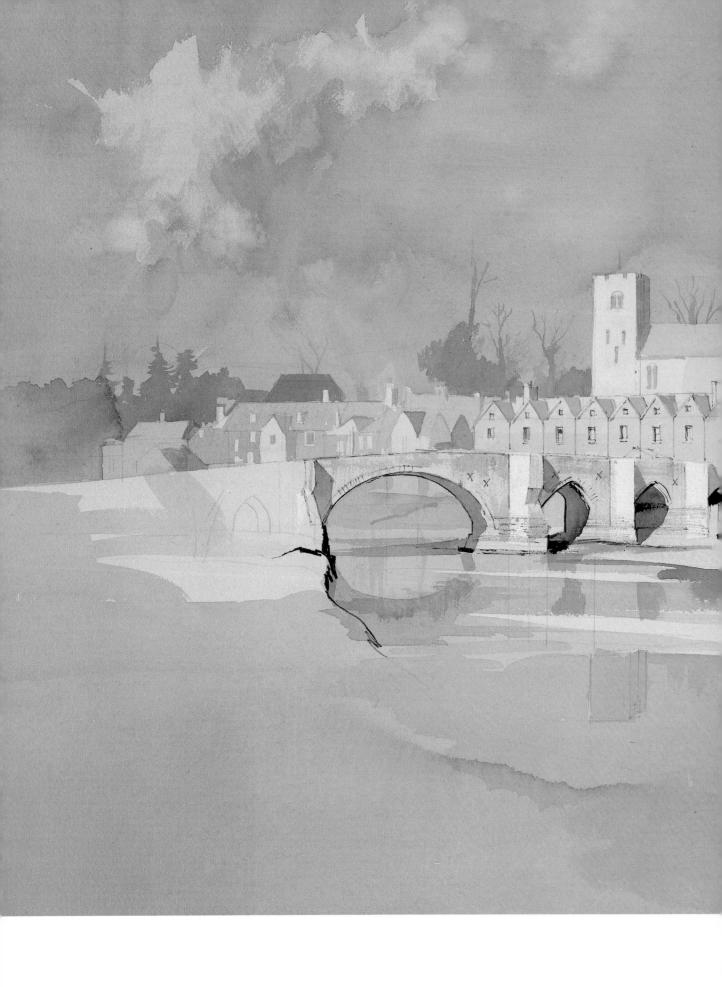

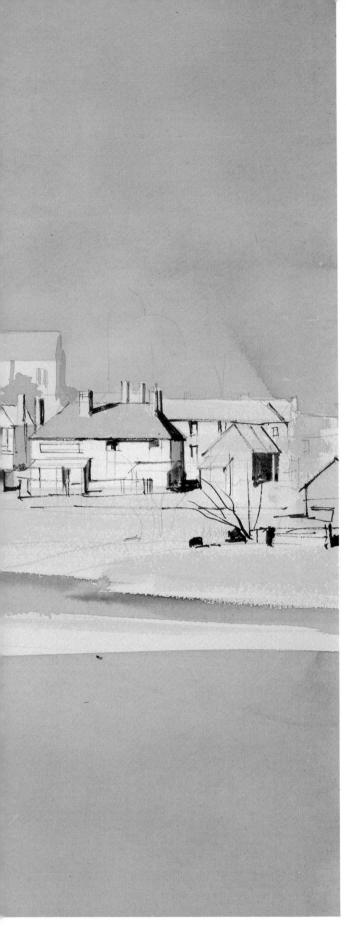

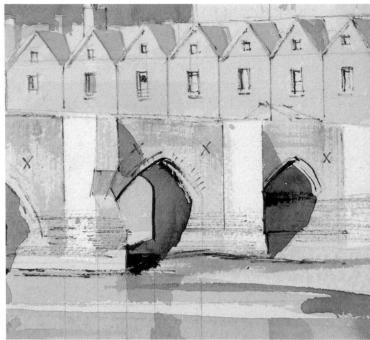

3. The painting was now ready to receive a wide range of color and tone, and I set about this process by balancing warm and cool colors. I mixed a wash of cobalt, added a touch of ultramarine, and brushed it from the top left-hand corner downward and to the right, leaving light areas with hard edges. I decided to break this up and dragged wet color over the hard edges with a piece of paper towel, creating a credible effect of light and lumpy clouds. This blue wash established a strong head of cool color at the top of the painting, and to balance this, I began work on the warm-colored houses, using burnt sienna to enhance the warm/cool counterchange.

I worked in other neutral shadows under the bridge, for reflections in the water, and for the trees on the left-hand side of the horizon. The addition of trees in the center of the painting next to the church helped to soften further the impact of the ungainly cloud above. I had already muted it a little with careful manipulation of water and soft sponges.

I sharpened up some of the architectural features with lampblack and a fine sable brush. Suddenly, I began to feel confident that my plan of color and tonal counterchange was progressing in an orderly way and beginning to be effective in the way I had hoped.

The rhythmic counterchange of values among the houses, the bridge, and the reflections, shown in the detail above, seemed particularly pleasing.

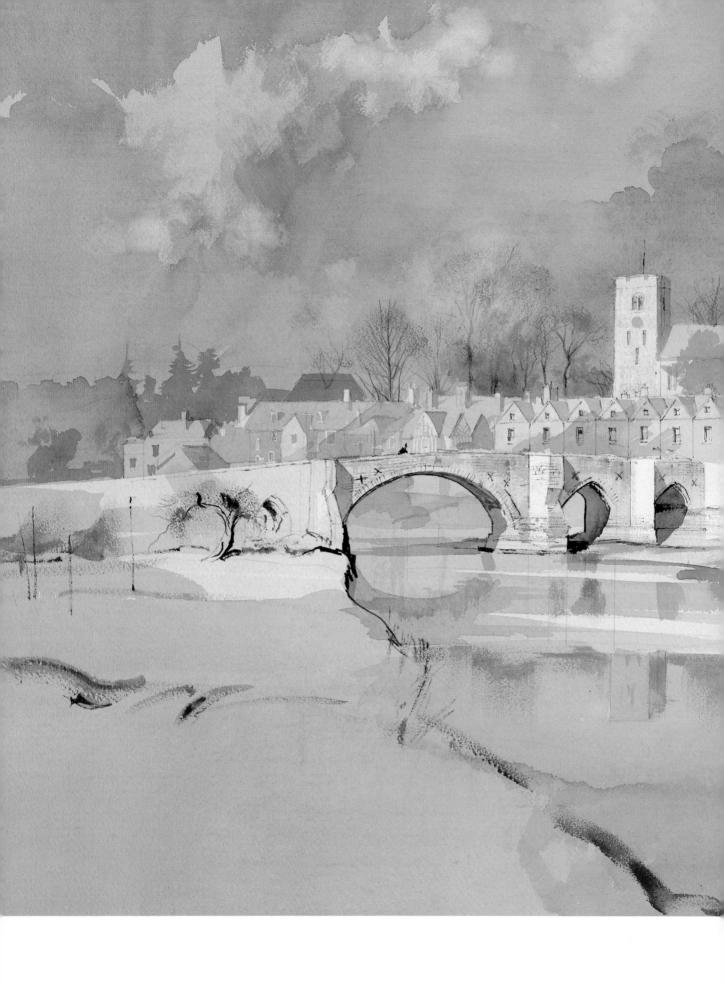

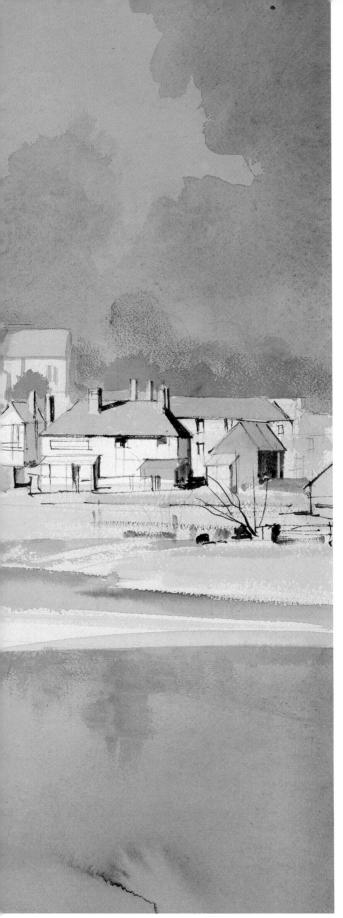

4. I continued working, but with a new enthusiasm, deciding immediately to intensify the sky on the right-hand side to show up the church. I began to work in the trees, allowing their green to act as a mid-temperature color between the cool sky and the warm stonework. I drybrushed some of the leaf areas, shown in the detail above, to soften the trees and create an impression of open spaces among the foliage.

The trees on the left of the church were too weak, and so I eased the sky tone to improve their impact and used drybrush to define their features more strongly. I continued the tree colors in the reflections in the water, once again creating a balance by introducing an area of related color in another part of the painting. The apposition of dark and light, warm and cool, was carefully woven into this painting, producing a strong and interesting interpretation of a simple country town.

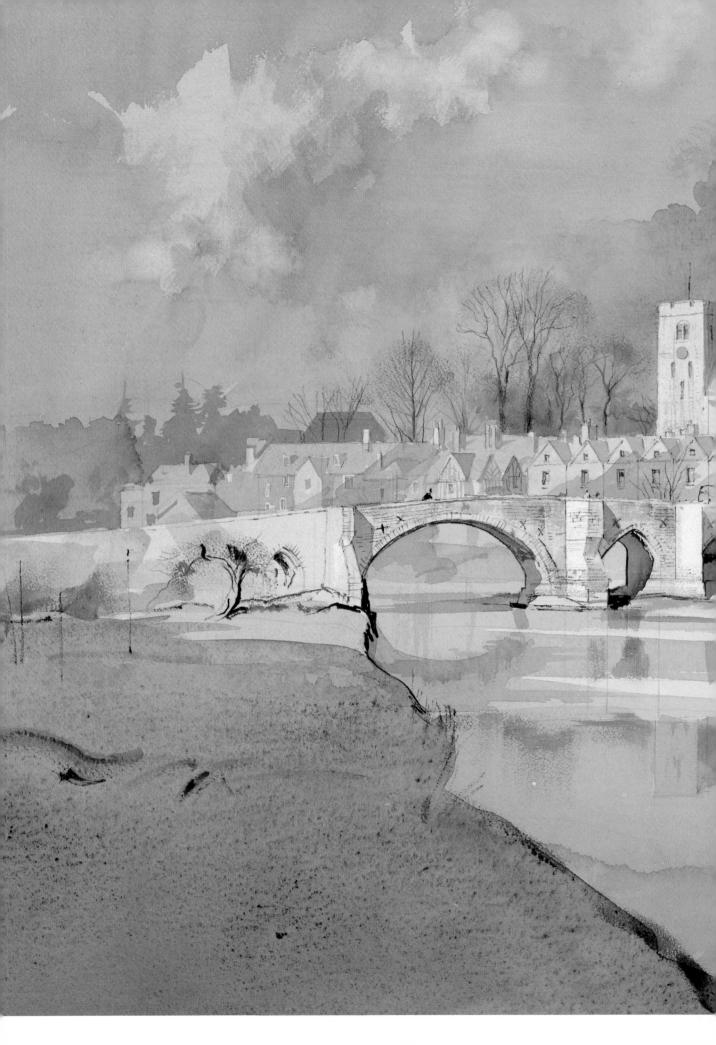

5. Not far to go now. I strengthened the tree trunks behind the buildings and then laid an additional tone of raw umber over the foreground. When this was dry, I laid another wash of lampblack over the bank in the foreground and allowed it to dry with the board flat; this created hard, reticulated texture on the shore.

I used a fine sable brush to do some more detailed drawing on the bridge and buildings, defining features and identifying characteristics where necessary, but never doing more than infering these points. I put in tiny patches of unrelated color on the front of the large building on the right, just to provide a complete change from the existing range of color.

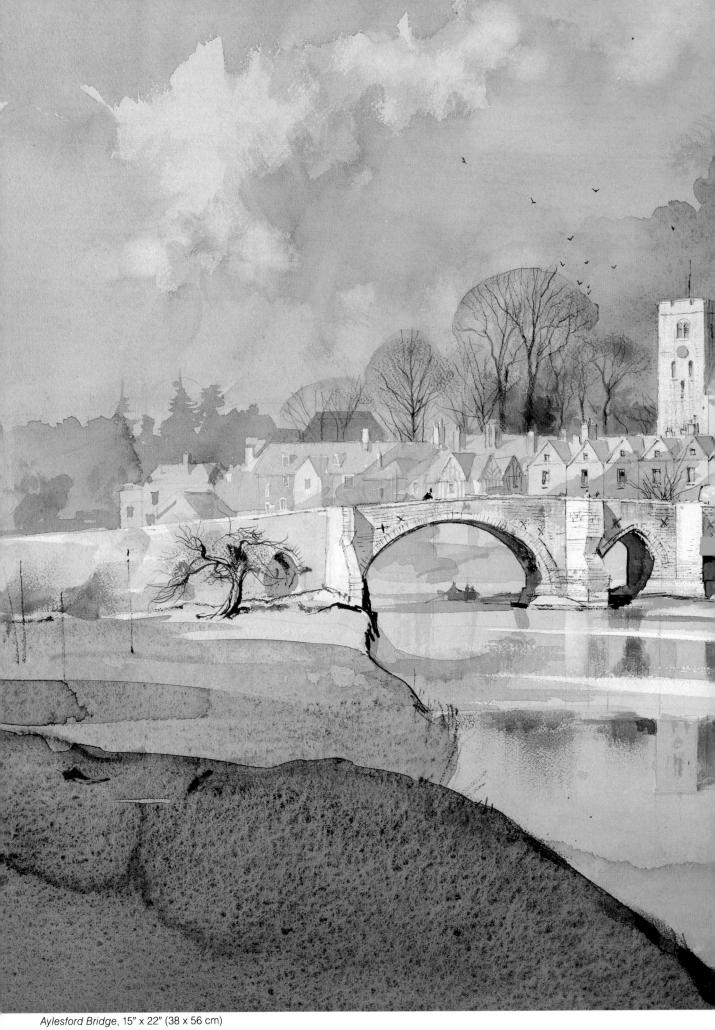

6. I finished the trees by laying a fine wash of burnt umber with a touch of black over each entire shape. Next I tightened up the drawing on the bridge and houses, noticing at the same time that the painting lacked any sign of life—and so I painted a boat, birds in the sky, and two boys on the shore. I was tempted to add more drawing to establish features on the left of the painting to match the right, but this would have made the painting overdetailed and too tight, and so I left it alone.

To balance the foreground and bring it nearer, I laid a wash of lampblack, leaving it to dry unaided. When studied, this bank looks too harsh, but the painting is about the bridge and town, not weeds and a mud bank, and so it is only necessary to establish foreground tones and not exact features.

The last brushwork on this painting strengthened the reflections in the water. After that, I laid aside the brush and scratched in the water highlights with the side of a razor. I had reached the end of a long spell of concentration and was well pleased with the result.

Unraveling a Complex Subject

Some years ago, a group of professional people that included myself formed a small company and purchased a large house, which after some conversion provided good accommodation and gave me an excellent studio in the heart of the country. One of our favorite walks was through the adjacent grounds of Knole Park, a large estate which we humorously referred to as "the house next door."

I chose to paint this large, beautiful house in winter, for in the summer it was largely obscured by the trees in full leaf. In fact, even in winter it was not much easier to select a view that made a good portrait of the complete assembly of buildings. I had to "thin out" some of the tree branches to convey an impression of most of the house.

As this subject really exists and I had not imagined it, it was extremely important to make an accurate interpretation in watercolor. To collect and amass factual information, I made numerous notes from drawings, prints, and existing photographs and took photographs of specific architectural details. I studied all this material and then made a preliminary drawing on ordinary layout paper, using charcoal to block in the main shapes. I made adjustments by dusting the charcoal away. leaving a faint image that I consolidated in pencil. I taped finished portions of the drawing together, made a final tracing, scaled it up, and taped it into position on stretched watercolor paper, using a T square to ensure that all the uprights were vertical.

1. My main reason for not making the preliminary drawing direct on the watercolor paper was that constant corrections and adjustments would have damaged the pristine surface of the paper. Often, even the gentlest use of an eraser roughens the paper enough to cause a flaw in a clear, flat wash.

To make the tracing, I used a thin sheet of layout paper which I had covered entirely on one side with graphite from a thick, soft lead refill. I traced down the drawing with a red ball-point

pen (so that I could see where I had already worked), pressing firmly enough to ensure a clearly traced image. Once the tracing was completed, I began to draw the architectural features with a fine-nibbed pen and india ink, adding the trees with a very fine watercolor brush. Then I followed my usual procedure of establishing the darkest areas in black. I used warm washes of sepia watercolor for the shadow sides of the buildings and burnt sienna for the tiled roof areas.

2. With a subject as complex as this, it was essential to work slowly and build the architectural structure piece by piece. This subject looked extremely difficult, but it was quite possible to paint it with careful planning and organization in the preliminary stages. The shapes and forms were all finite; so far there was little variation in color. Accuracy of construction and tonal harmony were the important features to consider at this stage.

I continued to create lighter tones by putting in some light washes of neutral tint to indicate shadows of trees and clouds cast on the face of the house, as shown in the detail that appears below. I put some deer in the middle distance but was still searching for an idea for a strong foreground. Perhaps a fallen tree would do? In any case, I still needed a study of something suitable. My concern with a foreground subject indicated to me that intuitively, I was satisfied that the building was nearly complete. I took a break.

3. When I returned to the painting later, it struck me that the deer could provide the foreground interest I was looking for. I hunted through my studio for photographic references and composed a group of animals on layout paper. I traced them down and inked in the dark areas, taking care to keep their shapes and silhouettes as simple as possible. They looked good.

Now for the earth and sky. I laid a fairly strong wash of burnt sienna over the whole picture, except for the light side of the house, which was left white.

Next, I painted some deep washes of raw sienna and black over the fore-ground area and then I drybrushed some light washes of cadmium lemon and black over the paler areas of middle-distance grass. I stopped and let these washes dry, during which time I decided to remove the deer in the middle distance to keep the setting for the house as simple as possible. I did this by scrubbing with a small bristle brush and blotting with absorbent paper towel. Much better!

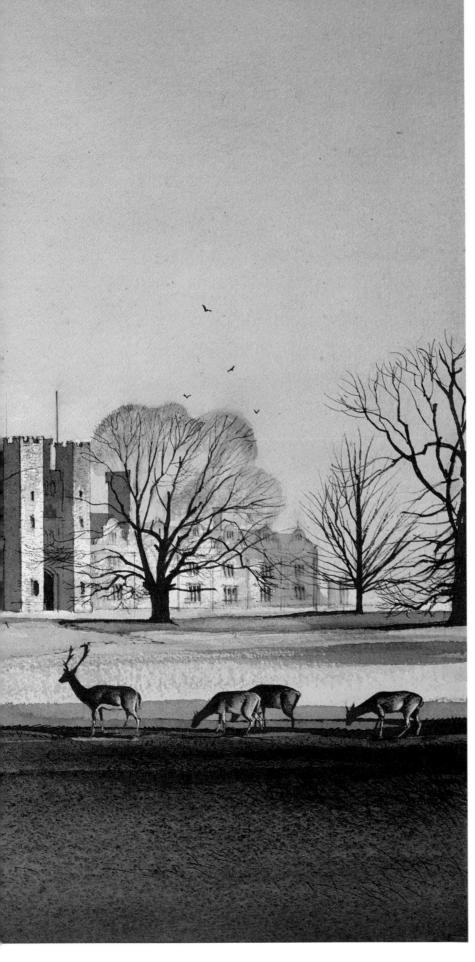

4. The painting was now ready for more color, and so I began by underpainting the sky with a wash of cobalt and phthalo blue. I made up this wash in two different strengths, one weak and the other dense. I turned the board upside down, tilted it toward me, and began by painting around the building with the diluted wash; by gradually introducing some of the denser wash, I managed to achieve a reasonably good graduated tone of blue. As soon as the color began to dry, I used some absorbent paper towel to blot out a light area to simulate clouds.

To complete this stage, I strengthened the foreground, causing the house to appear more dramatic.

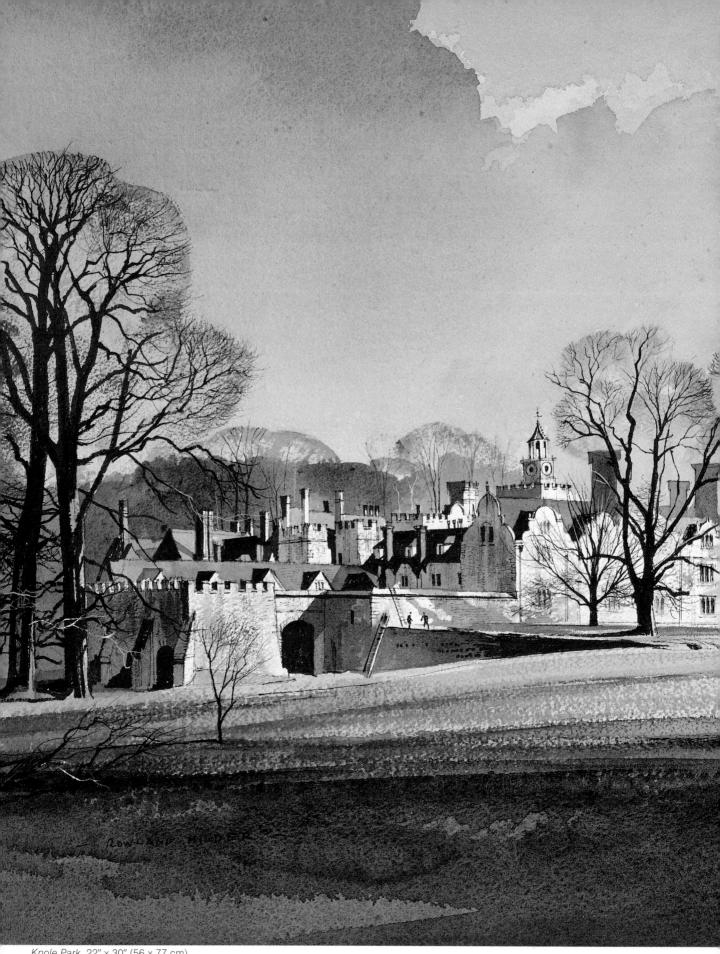

Knole Park, 22" x 30" (56 x 77 cm)

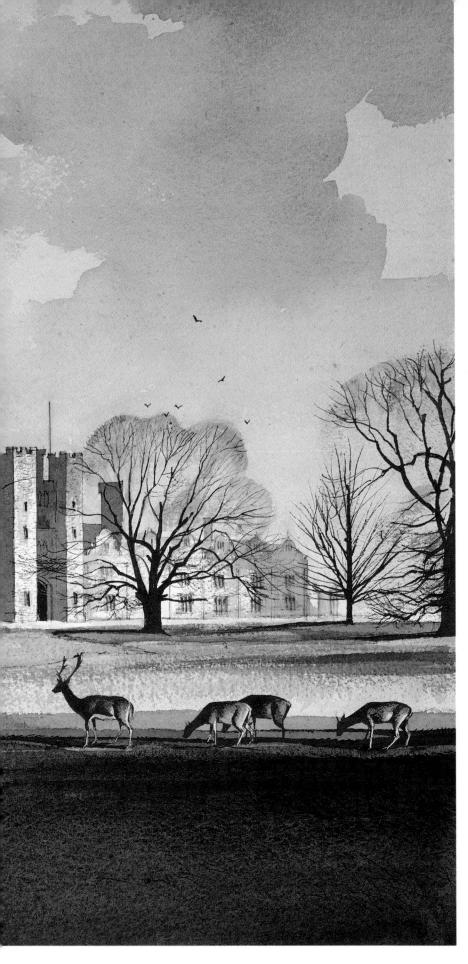

5. Now for the final washes and details. I overpainted the clouds in the sky first, so that I could work on the lower areas while these parts were drying. I began by painting the left-hand side with a wash of cobalt, ultramarine blue, and Indian red. As before, I mixed washes in two strengths, one intense and the other weak. I started at the top with the intense wash, making a hard edge against the underpainted blue and against the lighter cloud area in the top center, diluting the wash as it descended toward the buildings. Then I added light red and yellow ochre to the remainder of the washes.

Moving to the column of cloud on the right, I painted a hard edge on the extreme right but broke the edge on the left and graduated the wash as it descended toward the buildings.

I strengthened the foreground washes again, added a blush of color to the edges of some of the trees, and then went over the painting slowly, looking for areas that needed touching up. Two more rooks to the right of center, and it was done.

As in the painting of the paddle steamer on pages 80–87, it was essential here to maintain accuracy of definition and keep the main subject unclutered. Notice that the sky is simple and that the movement in it is right at the top of the picture. This movement is necessary; the lack of sky activity in stage 4 leaves the painting looking very static.

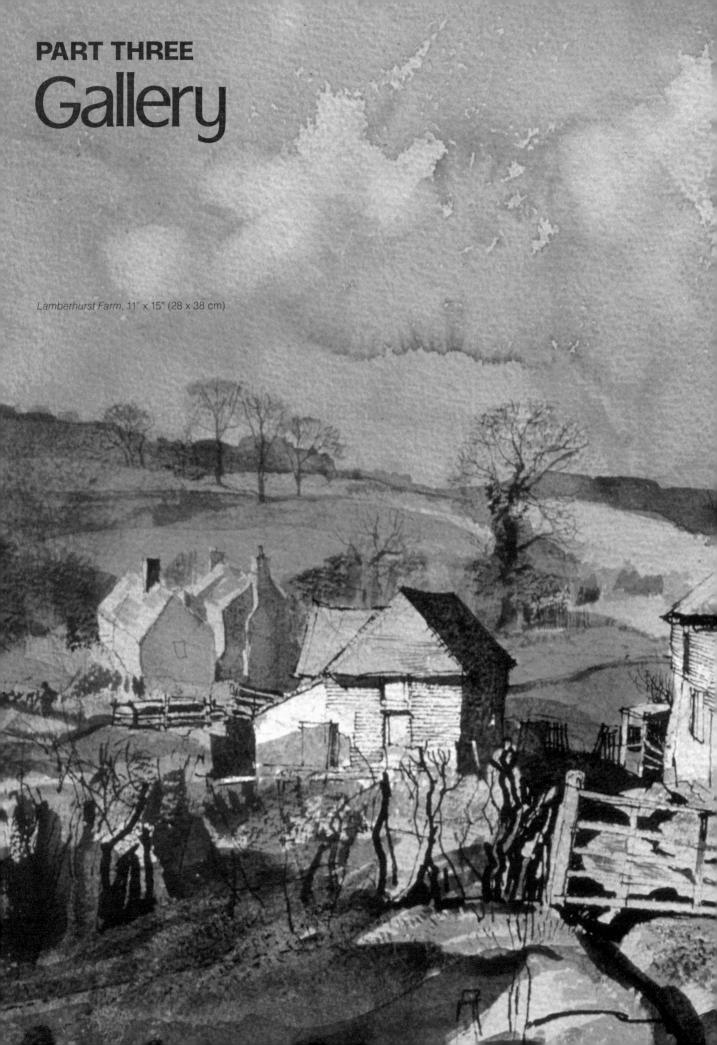

Plowing in the Fall, $11" \times 15"$ (28 x 38 cm)

This simple watercolor, which has a pleasing freshness, was made in my studio from sketches. My main intention was to capture movement in the sky, and I achieved the effect of fast-moving clouds by painting strong shadows over parts of the landscape and by putting in birds milling about in a light breeze above the earth. I worked quickly; most of my time was spent waiting for washes to dry.

The light tones in the distance, behind the darker foreground and middistance tones, greatly enhance the recession; they are simple, yet highly effective. I painted the plowed field very loosely so that it would play a subordinate part in the composition. Washes of warm yellow ochre underlie large areas of the painting, and these are offset by the subsequent washes of cool grays and blues in the sky. I used cerulean blue for the gap in the clouds; this color is permanent and stains strongly. It is difficult to apply in a large wash and granulates when drying, but for all this, its rich pigment makes a good contrast against the other earth-based colors here.

I used a razor blade to pick out a few glistening leaves in the mid-distance and left the work at that stage. I think this painting works because I did not "fiddle about" with it during the later stages. It's what I call a "good, controlled accident."

Mijas, Spain, 15" x 22" (38 x 56 cm)

This small town is high in the hills along the south coast of Spain. Years ago, before the place was invaded by tourists, I made many drawings of it. The building on the hill doubled as the church and the bullring—a curious combination indeed.

This painting was an elaborate portrait of the town, and I wanted to capture its architectural character and the strength of the local light. The town and the landscape were constructed with ochres, umbers, and siennas, and I used ultramarine blue and light red for the sky. In order to provide visual interest among the complex tussle of roofs and walls, I used black ink for the shadows between the tiles and left clear white paper for the parts of masonry in direct sunlight. This extreme contrast of values gives punch to an area of jostling shapes. The subject was difficult to handle, as it is exactly the sort of composition that can look tedious and overworked. I was aware of this danger before I began, and to ensure against a too tightly worked painting, I decided to keep the sky simple. This solution provided visual rest from all the activity created by value and color contrasts among the town buildings. One lone, barely suggested dark figure adds a touch of life to an otherwise barren

I was perplexed about how to interpret the walls of the buildings along the street. In a village like this, the houses are of a simple cement-and-sand construction, painted white. Unless they are painted regularly, however, the walls dull and take on a scruffy look. To enhance this character, I used a very dry brush of yellow ochre, which provided texture and grain without darkening the overall value. I used a rough paper for this painting and brought out its texture strongly on the right by scrubbing away dried color with a sable brush, leaving more pigment in the pits of the paper surface than on the top.

Staithes, 15" x 22" (38 x 56 cm)

There was a splendid view of this town from the high land behind it, and the light coming from the right produced a wide range of warm and cool, light and dark tones. Capturing this unusual balance in watercolor presented me with a real challenge, and there was the added complication of highly detailed architecture to cope with as well.

Drawing the town was a headache, as the buildings jostled each other at all angles and planes and almost every one was out of alignment with its neighbor. There were no quick ways of overcoming a problem like this; it simply demanded intense concentration, observation, and a new eraser!

First, I decided that this painting was about the town, and so everything else had to take a secondary role. (This is one of a few of my paintings where the sky plays only a small part in the overall picture.) All the dark tones were in one place, and so the lightest tone had to appear at the visual opposite of this: the cliff face at the top left-hand side. The river bisected the two and led the visual interest out into the distance. The small boats on the water contained some dark shadows, echoing the tones of the buildings. Without them acting as a link between dark and light, the painting would be too harshly divided. As with many paintings, once I had argued this out with myself and planned the work, the actual painting was quite straightforward.

In style, I worked on the town with precision but treated the cliff on the lower left-hand side extremely loosely; it is suggested by just a few very rough, seemingly coarse brush marks.

The Creek at Oare and Faversham Junction, 15" x 22" (38 x 56 cm)

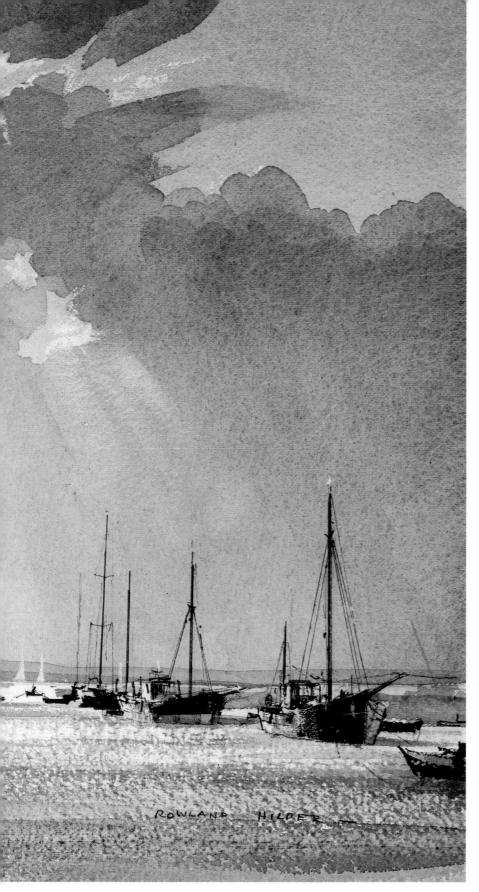

This place is one of my favorite play-grounds and is only four miles from our coastguard's cottage. We sail up with the tide to Holly shore, have a quick drink while the water is high, and then sail back with the ebb tide. One man, who had stayed for more than a few drinks, returned to his boat to find it roped to the pier completely out of the water. In panic, he cut the rope at the stern, only to see the back of the boat plunge into the mud with the bow still attached, looking like a rocket.

Here, a fishing smack is running with the wind on the last of the tide. The sun is directly ahead but hidden behind a cloud, creating a dark foreground and a light mid-distance. I underpainted the sky with a warm tone and used light red and ultramarine for the cool areas, leaving the paint to dry flat to produce a strong granulation. As there was little land, I completed it quickly and then worked on the boats. I was keen to create strong lights in the sky and water and used drybrush to make the textured effect of light on the sea, gaining maximum advantage from the paper surface. I left some of the paper completely white in the distance for the strongest light and then used a razor blade and opaque white on the clouds directly above. Between these two areas, I lifted out streaks to represent light shafts coming down onto the water. I made some smoke above the sailing craft in the center by washing away the edge of the barn.

Even though I have an affection for this place, the reason I like this painting is because it has a good balance of tones and textures.

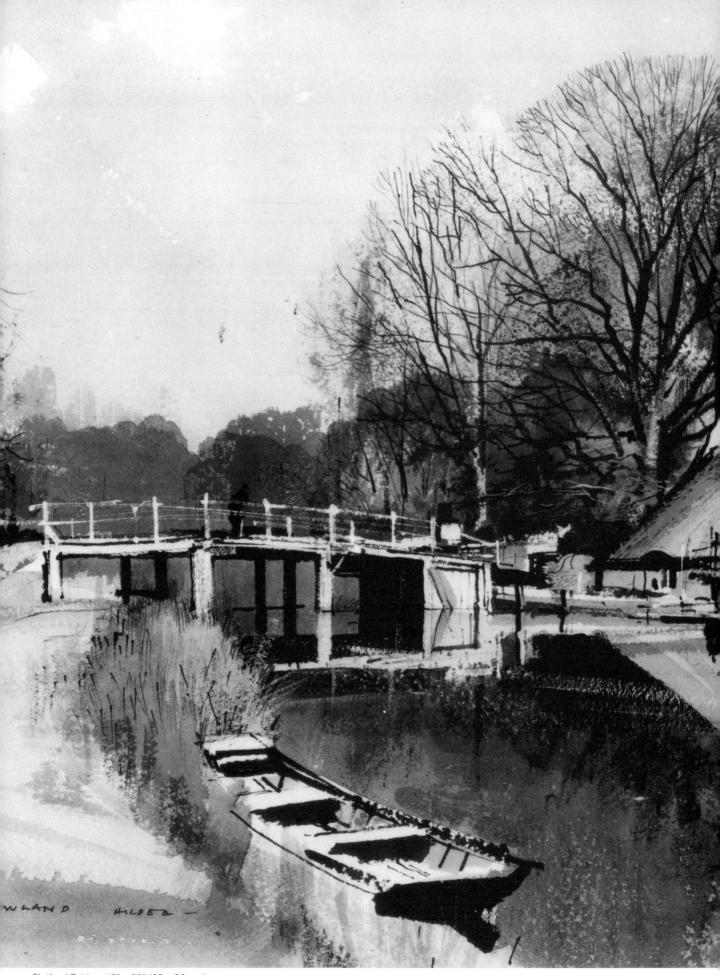

Flatford Bridge, 15" x 22" (38 x 56 cm)

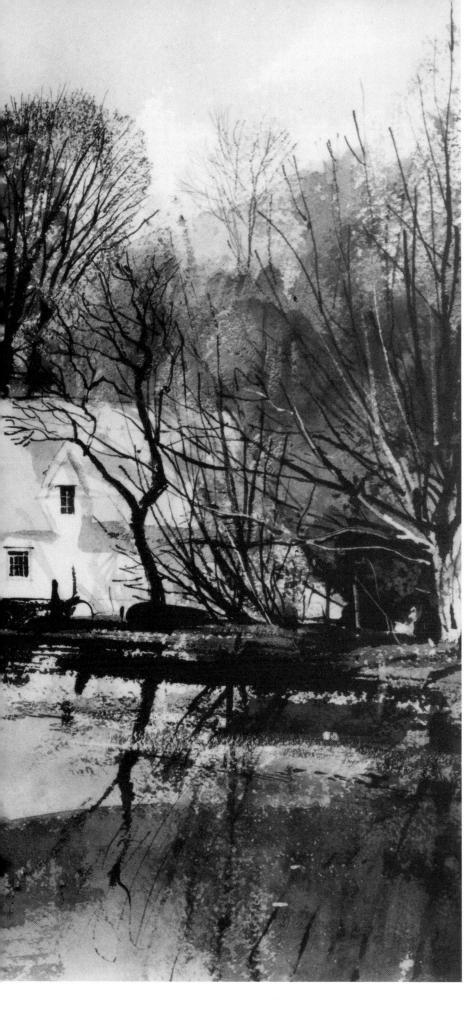

This cottage is on the river Stour, which flows through the heart of Constable country, a part of Britain that has all the attractive features that excite a watercolor painter. Perhaps it is no coincidence that this is one of my favorite watercolor sketches.

This picture contains successfully executed examples of all I strive to achieve in my painting. It works as a complete statement, it composes well, it has strong atmosphere, and it has just the right combination of wet, flowing watercolor and drybrush work. It was painted in a loose, easy style, but at the same time it appears to contain detail and intrigue. The dark water on the extreme lower right-hand side is murky but interesting, without being too heavy in tone. The cottage has character, without being too pretty. I'll stop there: sometimes it's nice to enjoy simply looking at a satisfying piece of work.

This was a loose sketch begun on location and completed at home. I laid a wash of burnt sienna and black over the entire paper surface, except for the yacht in the foreground. I laid a dark gray across the top right corner, graduating it into a lighter warm gray, and then added a faint wash of blue. The mud flats were a simple color scheme of warm, earthy tones. The sailing ships' hulls were suggested, rather than drawn with great precision.

The two pools of water left behind by the ebb tide were created by simply leaving gaping holes in a lampblack wash. If you think about them, they become incongruous, as does some of the color and drawing on the bow of the large vessel with the anchor on the right. In the case of the water pools, I did not try to paint the water, but laid the right preliminary wash and then put in the mud around them. It looks like water because that is what we expect to see there, and the tonal value is true.

The bow of the sailing vessel has a seemingly casual array of colors dashed in quickly, to insinuate the trappings that usually hang over beached boats. Whether they are shadows, patches of rust, flaked-off paint, or just dirt, they look right in context. I made no attempt to draw or define any single item within this area, and the result is pleasing mainly because of this lack of focal interest.

Notice that the yacht in the foreground is lighter in tone than the clouds. Throughout this painting, I concentrated on the development of light against light, so that an ordinary boat scene contained movement and tonal counterchange. I am often more satisfied with a loose, intuitive painting like this one than with a carefully constructed "blockbuster" like Knole on pages 98–107.

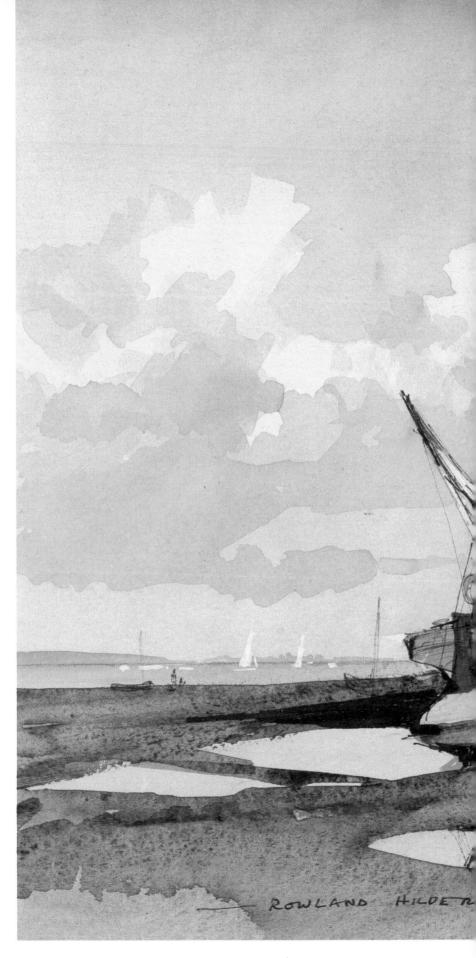

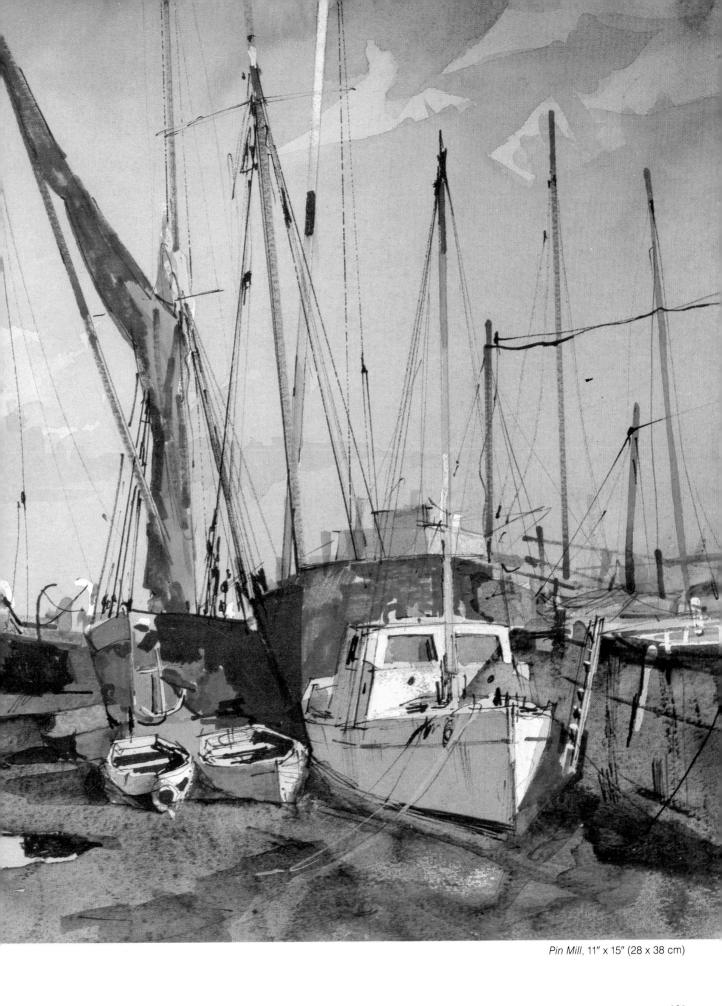

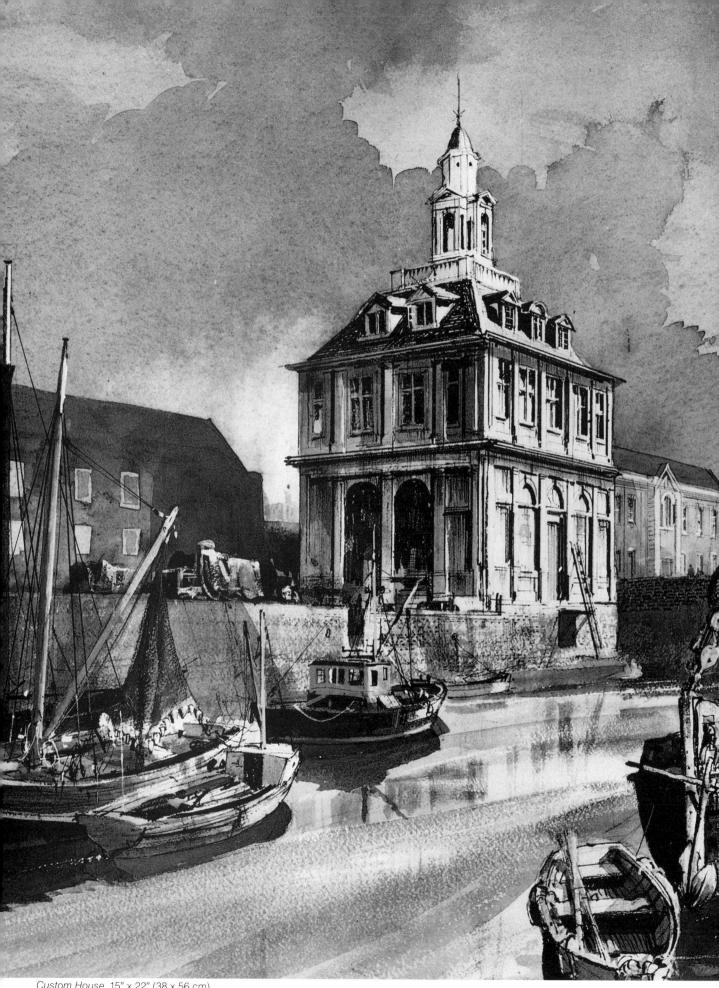

Custom House, 15" x 22" (38 x 56 cm)

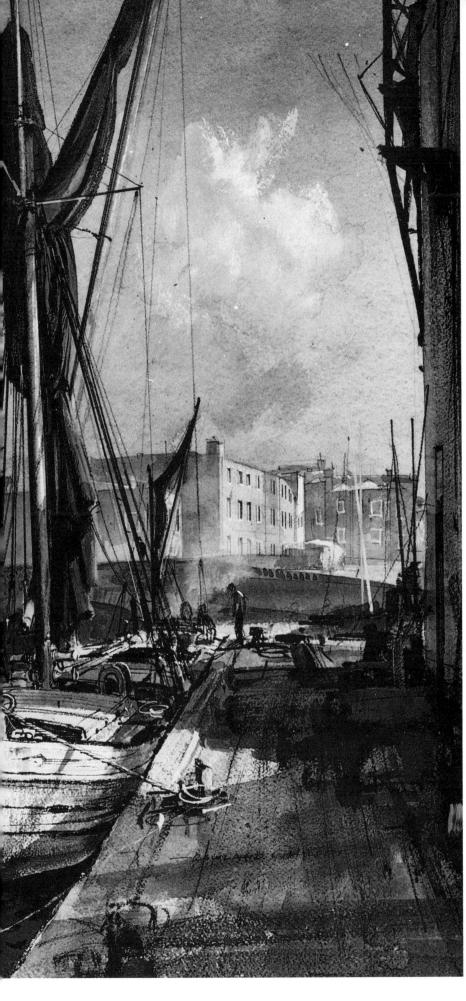

This painting contains some accurate architectural drawing. In order to not make it an extremely difficult painting to handle, I used a T square to ensure that the walls, windows, and pillars would be perpendicular on all the buildings. I did not want this painting to be purely a mechanical drawing, and so I decided to make the ancient custom house the center of attention and paint everything else much more loosely. (Notice how loosely I have suggested the building to the left of the custom house.) After having completed the custom house, I worked back along the other architecture on the far side of the water. I decided that a row of pristine buildings going into the distance would be boring, and so I created a light pawl of smoke at the back of the sailing craft to break up some of the sharper architectural details. As I have a passion for boats, and take great joy in recreating their specific parts, I couldn't resist tinkering with the blocks and tackle, rope, and sails on the ship.

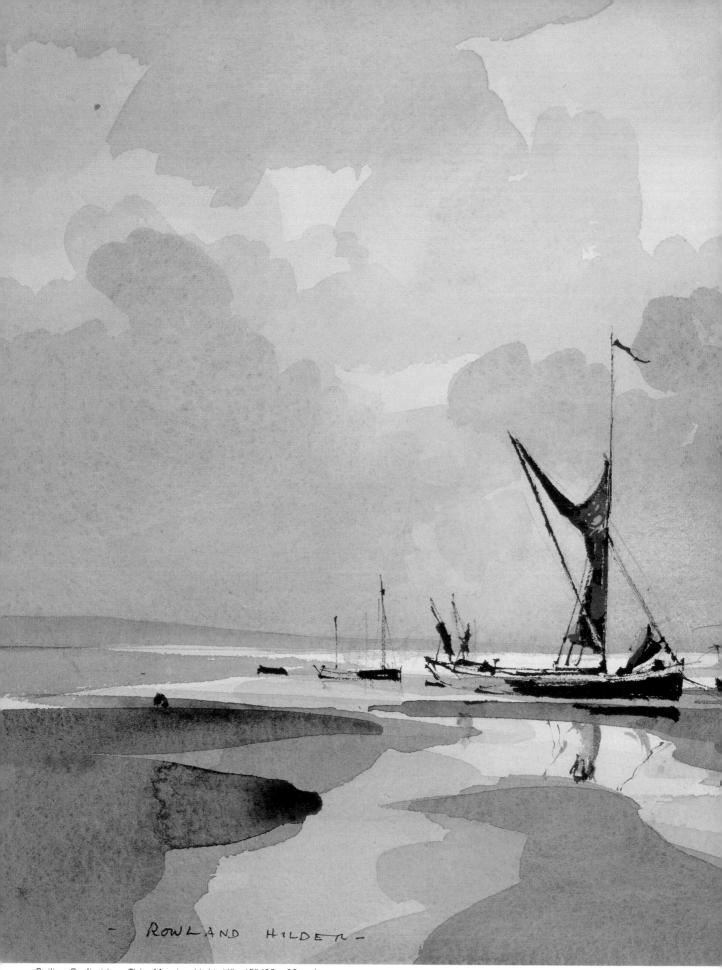

Sailing Craft at Low Tide, Morning Light, 11" x 15" (28 x 38 cm)

This sailing craft has a long pennant at the tip of its mast, indicating that it won the local seasonal race. Morning light spreading across an estuary at low tide is a sight I have seen many times. I made this painting in my studio, keeping the board flat all the time so that the washes would dry evenly and would also granulate. The color was similar all over, and so I put a basic wash everywhere except on the distant water. I laid a graduated wash of blue merging into ochre from the top of the sky downward and also in the lighter water areas. When this was dry, I put color on in puddles and left it to dry undisturbed. I used some Indian red in the sky along the horizon and made the foreground mud a warm mixture of ultramarine and light red with a touch of raw umber. I washed out some of the mud on the right, as it was too heavy and even in texture.

There is a simple, sketchy "feel" to this painting that suits the early morning calm extremely well. When I was a small boy, I sailed up the River Thames in a hired boat from Woolwich to Tower Bridge. In those days there was a great amount of activity on the busy water, and multitudes of boats of all sizes were carried up and down the river by the wind. I made this painting mostly from memory, referring to sone old engravings for some of the finer technical points. The Prosepct of Whitby is a famous drinking house beside the river. It still exists.

I made the water extremely brown and dirty, which is exactly as I remembered it. As this lively scene has many subjects jostling for pride of place, I assembled each of them on tracing paper and arranged the composition first before starting to paint. I get a great deal of satisfaction from looking at this scene of days gone by and sailing vessels that no longer exist. I'm pleased I was able to capture them as they looked in their heyday.

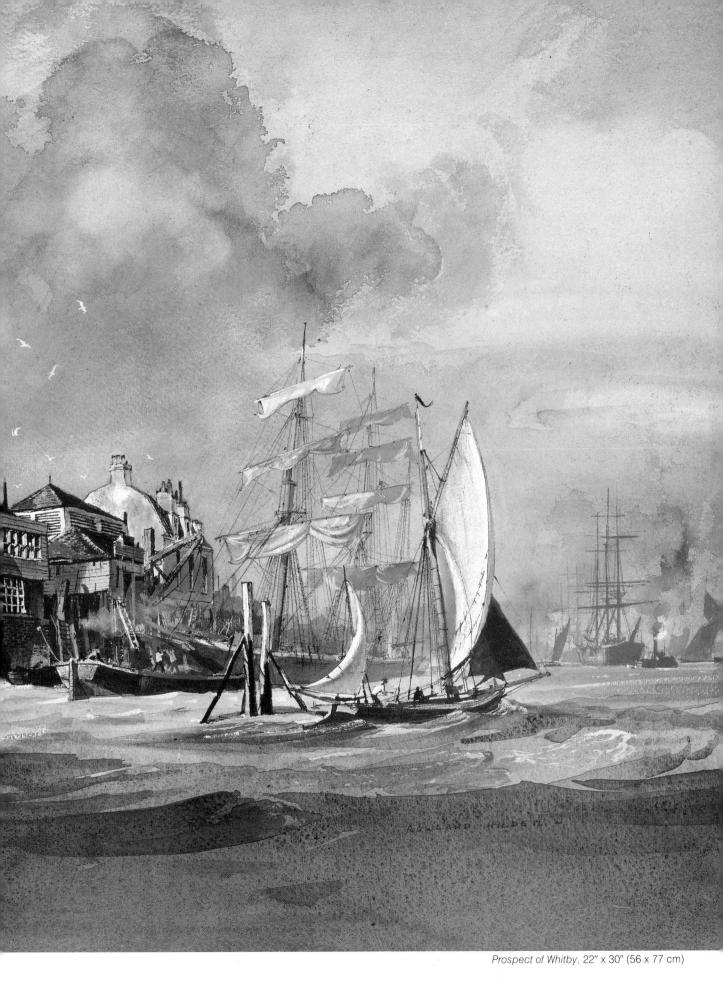

Sailing on a moonlit August night is a rare experience. I made this painting from memory and from sketches done during the day of the landscape, and the hut on legs. I wanted to try to set the scene against the light path running down the center of the painting. A high moon (or sun) produces a wide path of light across water, while a low light source produces a narrow path. I was especially keen to paint the light passing through the sails of the yacht and to produce bright light without the use of gouache or any other substance.

I began by establishing the dark boats, and then I laid a wash of ultramarine and light red with a little ochre over the sky, leaving the sail edge and top sky as white paper. I left the lightest part of the hut roof yellow and then tackled the tricky operation of drybrushing the sea with sky colors to give sparkle to the water. I needed to keep the paint dark enough to establish the depth of tone at the first attempt, but without making the common mistake of producing heavy, dull tones. The paint looked too dark when wet, but it dried lighter and created the desired effect. In fact, it was a little too light, but I found it entirely acceptable, as freshness was more important than an exact match of color.

The foreground mud is warmer in tone than the far bank because I added burnt sienna and sepia to the basic color.

The red port light on the central sailing boat presented a problem, as red is a deep tone and appears as a dark and not a light. To solve the problem, I used an orange and graduated it to a white center.

Finally, I added some dark tones to the top of the sky, and when these areas dried, I sponged away some softer clouds.

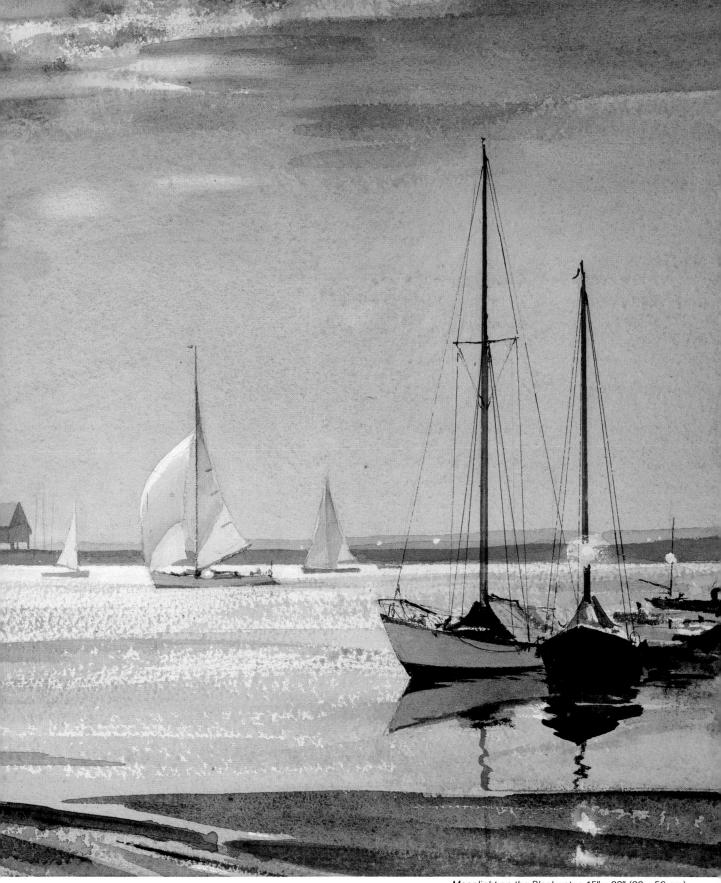

Moonlight on the Blackwater, 15" x 22" (38 x 56 cm)

Sussex Lane, 15" x 22" (38 x 56 cm)

I made this very simple, open painting on a warm winter day. I worked outside, used little color, and concentrated entirely on the juxtaposition of the busy hedge and tree detail with the vast, misty sky. I lifted out the graduated light area around the sun with paper towel while the wash was wet, so that no hard edges would be apparent. The giant tree to the right provides a link between the land and the sky; cover it up with your hand, and the composition becomes very dull. If you study the branches and twigs, you'll see the exact place where I stopped painting lines and used smudges of watercolor to create the finest twigs at the very ends of the branches. This is a very easy, relaxed painting, and I have used my own imagination to alter the actual scene wherever I pleased.

Oast Houses, near Shoreham, 15" x 22" (38 x 56 cm)

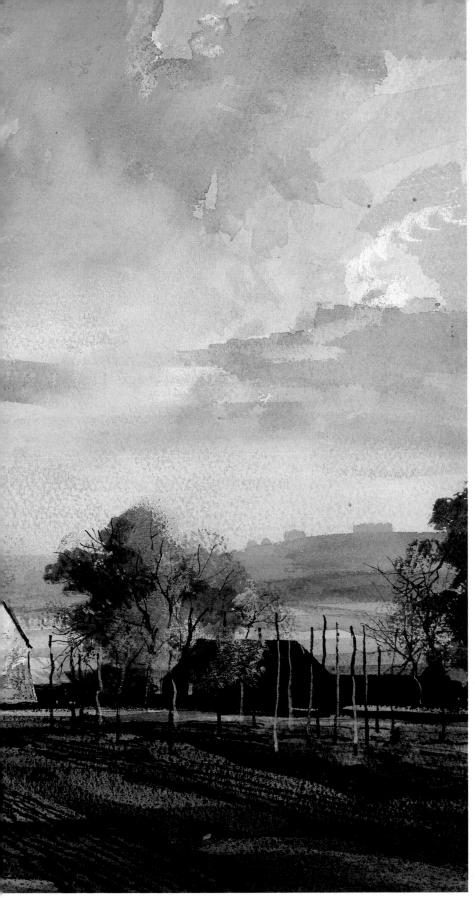

This painting contains many of my favorite watercolor subjects; a full sky with sun behind patchy clouds, leafless elms, and a wet, freshly plowed field. The sky is a development of the simple analysis on page 43. The lower clouds are set against the light, while the upper clouds stand out against the muted tones. I used a small amount of white gouache to give weight to the clouds above the elm trees. I overdid this, and the clouds in the lower half of the painting became too heavy, and so I lightened most of the sky just above the horizon with a soft sponge. The interplay between the opacity of the gouache and the tooth of the paper produced an excellent misty effect.

I used drybrush energetically on the foliage and achieved good granulation in the washes on the foreground field so that the strong tones and rich colors would complement the activity in the sky above.

I was pleased with this painting because I attempted a bold interpretation and managed to control all the strengths of tone, color, and form to produce a powerful result.

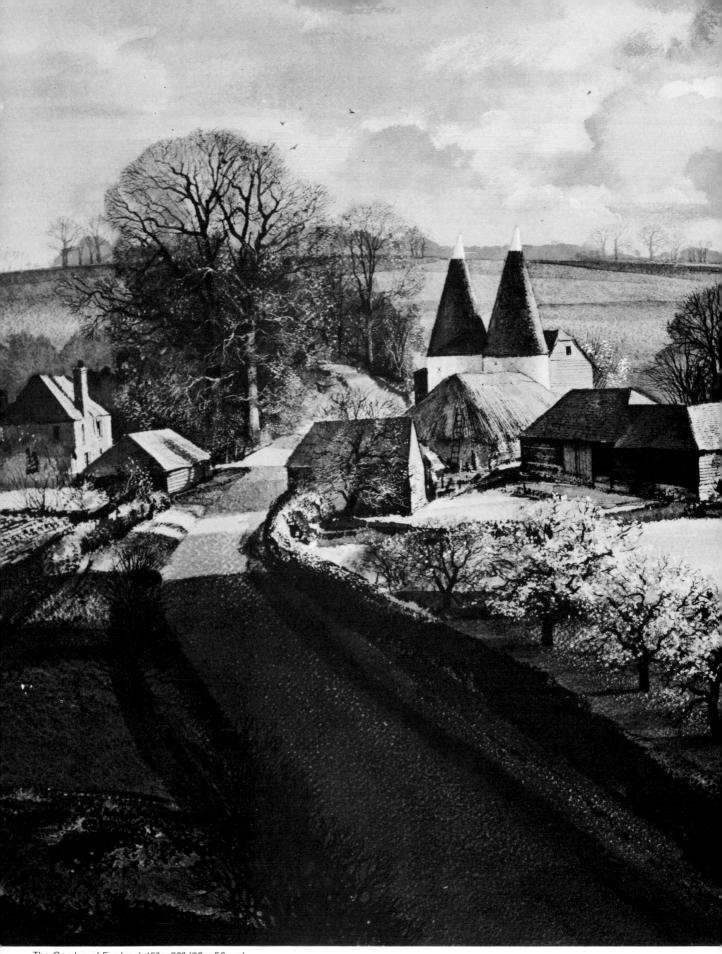

The Garden of England, 15" \times 22" (38 \times 56 cm)

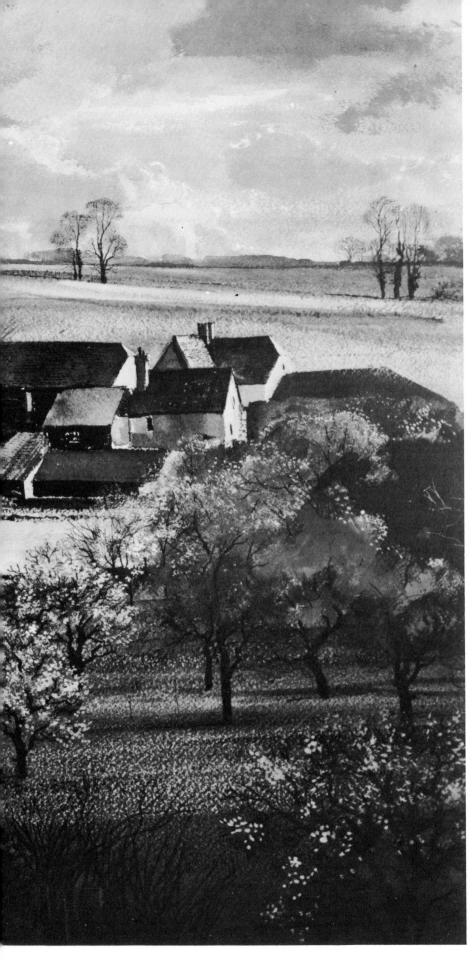

This delightful scene embodies most of my favorite subjects in the Kentish landscape. The strange-looking conical towers in the center of the painting are oast houses, in which hops were dried for making beer. Most of them are no longer in use, but as they were very sturdily built, they remain an integral part of most farm landscapes.

This is a very busy painting with much activity in the center of the paper. With this in mind, I was determined to play down the activity in the foreground, and so I cast a deep shadow across the lower third of the entire painting. I painted the scene on a windy spring day. The active sky had many cumulus clouds, but by keeping the cloud values within a close range, I muted their presence so that they would not compete with the visual activity among the buildings. I used exactly the opposite technique to create a strong interplay of planes between the walls and roofs of the buildings: there, the range of values goes from near white to almost black. I relied almost entirely on the interrelation between the values to give interest, keeping the fine detailed drawing to a minimum on and around the farm. The fields above the farm are very bland and provide a simple backdrop for the roofs.

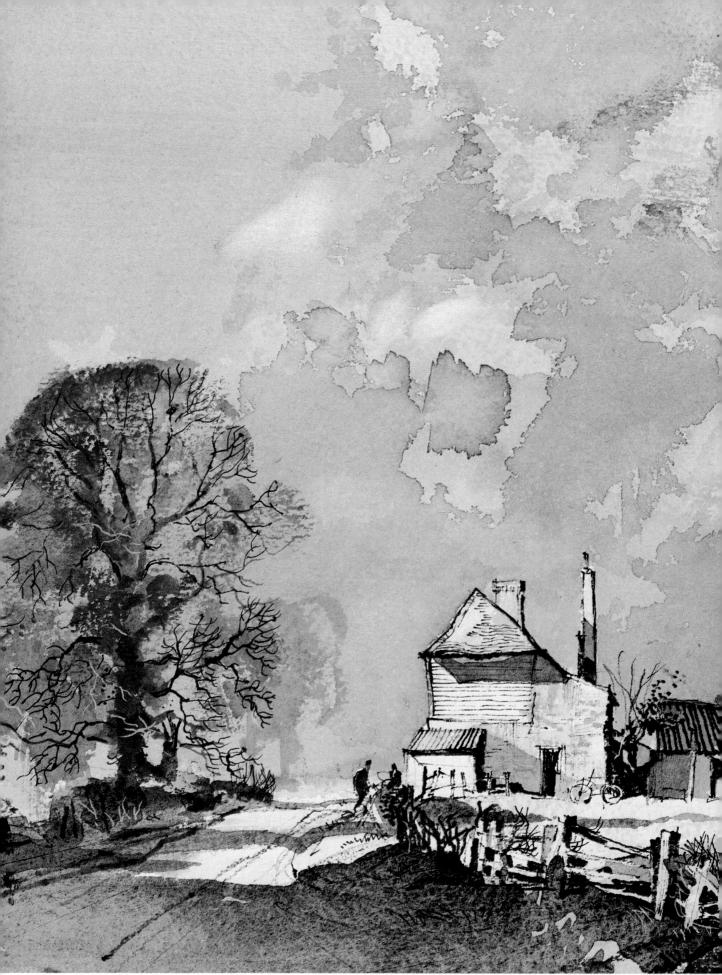

High Halstow, 11" x 15" (28 x 38 cm)

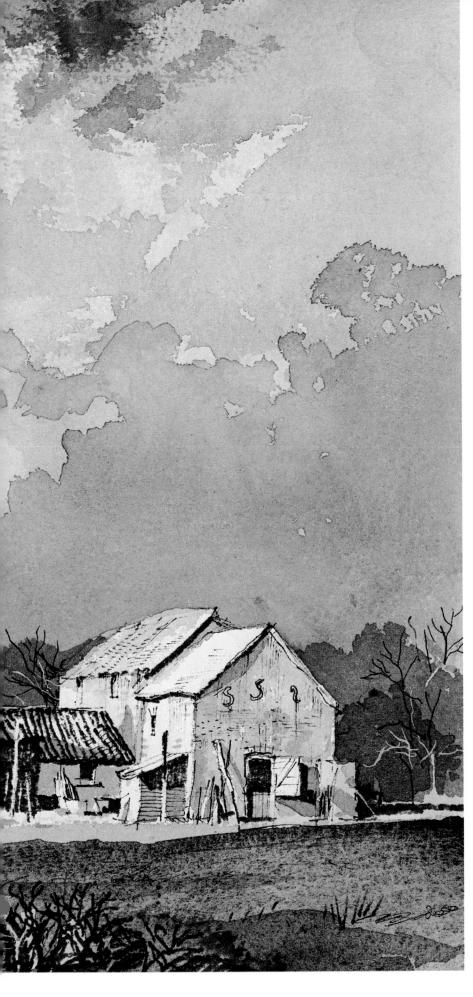

I made a drawing of this theme one crisp autumn morning, using carbon pencil and some very simple washes of lampblack. The drawing worked well, but I had been particularly struck by the beautiful color of the bright sun on the pale red brick buildings, and so I decided to make a painting from my sketch to bring out this particular effect of light on stone. For the painting, I didn't follow the drawing exactly: I added the fence that goes from the foreground to the largest building from the foreground to the largest building from another study I had made some time ago. Without this fence, the painting would have lacked interest in the foreground and there would have been no really strong lead into the visual center of the painting. The main house and out buildings were positioned exactly as I saw them, as their composition seemed to work well. I used a very loose treatment for both the sky and the immediate foreground so that all the interest and detail would be concentrated in and around the buildings. I felt that without some sign of life, the painting might appear just a little bit too still, and so I completed the painting by adding the bicycle, the figures, and other tiny details around the center of the painting.

I was very happy with the finished painting, which was purchased by the Queen and Duke of Edinburgh at the Royal Institute Exhibition.

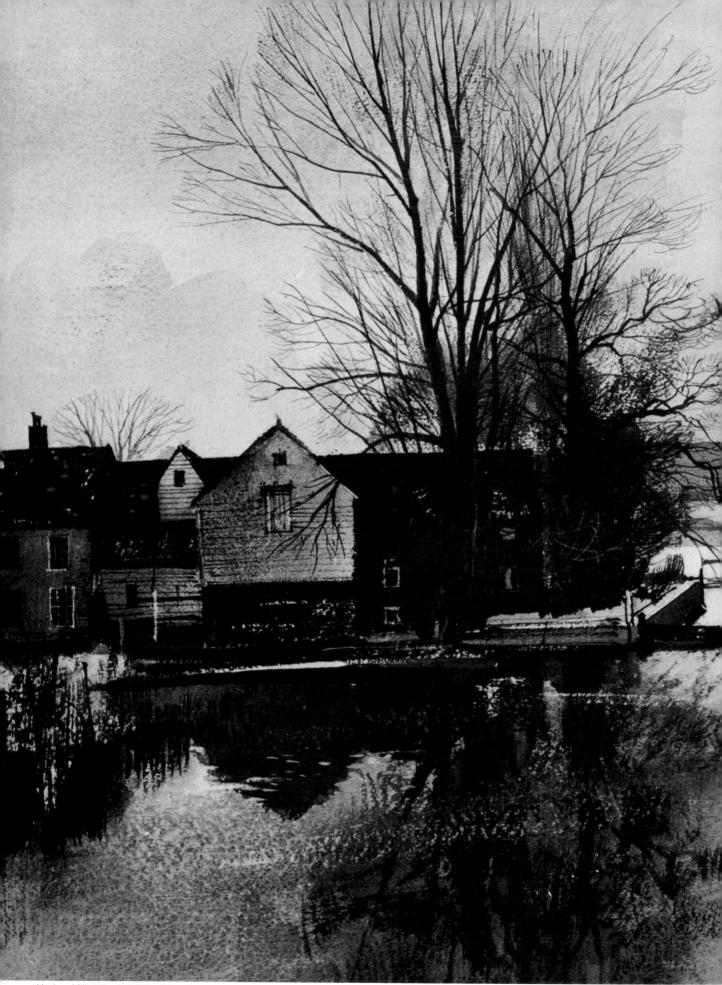

Harlow Mill, 15" x 22" (38 x 56 cm)

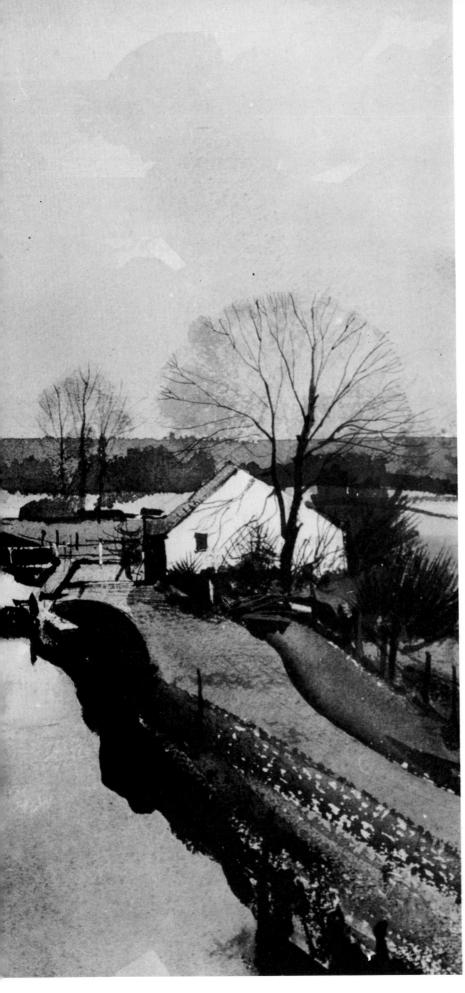

This ancient mill was set alongside a canal. I painted the scene from a bridge on a still day, and I decided that its most interesting features were the majestic trees in the center and the interesting shapes and textures reflected in the calm water. I painted the sky in an almost even tone with only a little granulation in the top left-hand corner. With a fine brush, I drew much detail among the branches and twigs of the two center trees. Their reflections in the water are much less clearly defined, and they make an interesting link between the middle of the painting and the lower edge. On the left side of the water, I used some dark, dry brush strokes on top of light washes to create high contrast and activity among the reflections. On the right-hand side of the painting, the drybrush strokes give a very good impression of the bank of the canal beside the towpath. The water in the lock is at a lower level than the water in the foreground, creating a sharp change in tone and leading the eye into the distant landscape. This painting is a good record of the mill, and I'm glad to have recorded the fine architecture, as most of it was destroyed by a fire some years ago.

A mill has stood on this site for nearly one thousand years, and this is one of the last remaining tidal mills in Britain. I had sailed past it many times and eventually made some sketches from my boat, with a view to making a large painting back in my studio.

The sky was painted with basic washes of ultramarine and light red, with some patches of the first color used almost pure and allowed to dry flat to encourage granulation. Subsequently I added cerulean blue on the right-hand side to give a colder, harder color to part of the sky. I scrubbed out highlights on the water with a bristle brush.

Throughout painting this mill, I maintained a free, open style, wishing to avoid any sign of tension in my brushwork. I drew the buildings accurately and painted them with precision, in apposition to the loose rendering of the sea and sky. Without this preplanned balance of styles, the painting might easily have become tight and stuffy.

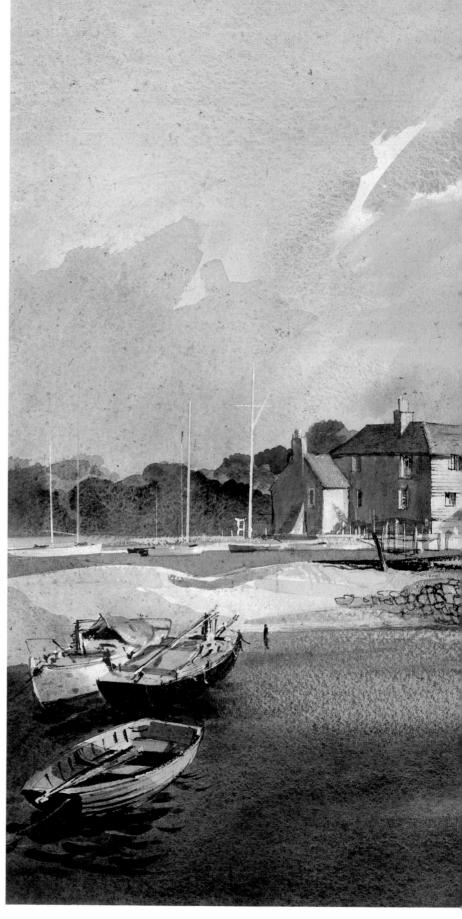

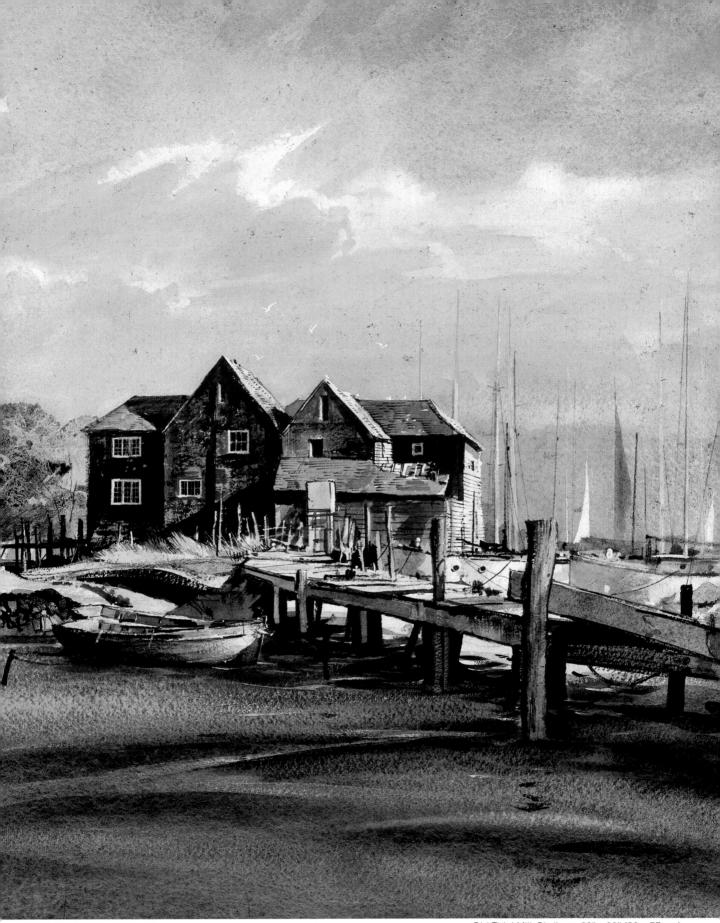

Old Tidal Mill, Birdham, 22" x 30" (56 x 77 cm)

Index

Accuracy of painting, 88–89, 101, 114, 126
of architectural details, 98, 122, 140
of nautical details, 64, 80
Aerial perspective, 24, 42
Alizarin crimson, 36, 37
Alterations, techniques for, 71, 103
Architectural structure, see
Buildings, drawing of
Areas of light, balance of, 56–63
Art, evaluation of, 14–15
Aylesford Bridge, 88–97
Azure cobalt, 37

 $\begin{array}{c} \text{Backgrounds, toned, } 16, 20\text{--}21, 25\\ \text{Balance of light areas, } 56\text{--}63\\ \text{Ballpoint pen, sketch with, } 18\\ \text{Blue pigments, } 37\\ \text{Blue-black, } 36\\ \text{Buildings, drawing of, } 88\text{--}97, 98\text{--}107, \\ 114, 122, 139, 140\\ \text{Burnt sienna, } 13, 36, 37\\ \text{Burnt umber, } 13, 36\\ \end{array}$

Cadmium lemon vellow, 13 Calais Pier (Turner), 15 Calcined yellow ochre, 13 Carbon pencil sketch, painting from, 137 Cerulean blue, 36, 37, 110, 140 Charcoal grav. 36 Claude mirror, 17 Cley Mill, Norfolk, 22-23 Clouds, 47, 67, 87, 107, 132 in complicated sky, 34 dark, 29, 61, 63 warm, 31, 34 white, and blue sky, 30 Cobalt blue, 37 Cobalt violet, 37 Cold colors, see Cool colors Color, 8, 36-40 mixing of, 13 tone and, 26, 27 "Constable" green, 13 Control, in loose treatment, 42–47, 132 Cool colors, 37, 65–67, 75, 91–93 Corrections, techniques for, 71, 103

Cotman, John, 15 Counterchange, 120 of pattern, 80 Creek at Low Water, 49–55 The Creek at Oare and Faversham Junction, 116–117 Crimson pigments, 37 Custom House, 122–123

Davy's gray, 36 Demonstrations, 8, 41 balancing areas of light, 56–63 control, in loose treatment, 42–47 complex subject, organization of, 98 - 107impact, in quiet painting, 64-71 mood, creation of, 72-79 movement, to capture, 80-87 sky, strong but subtle, 48–55 tonal patterns, variation of, 88–97 Detail, use of, 87, 122, 135, 137 Distance, illusion of, see Receding space Drybrush, uses of, 42, 47, 50–53, 75, for highlights, 117, 129, 139

Earth colors, 13
East, Alfred, 22
Emery paper, to create texture, 32
Erasures, 99
Exercises, 8
aerial perspective, 24
backgrounds, tinted, 20–21, 25
color added to tone, 26, 27
highlights, 32–33
scrubbing out skies, 28
sky painting, 22, 28–31, 34–35
tone added to line drawings, 18–19

Flatford Bridge, 118–119
Flint, W. Russell, 32
Foregrounds, 24, 97, 125
interest in, 101–105, 136
tonal values of, 49, 110, 117, 129, 135
French ultramarine blue, 36, 37

The Garden of England, 134–135 Graduated skies, 35 Granulated washes, 36, 37, 67, 117, 125, 132, 140 Grays, pigments for, 37 Green pigments, 13, 37

Halftone backgrounds, 16 Harlow Mill, 138–139 High Halstow, 136–137 Highlights, 32, 33, 55, 79, 87, 140 made with knife, 27, 32 made with razor blade, 55, 69, 79, 97, 110, 117 Horizons, 49, 51, 55, 81, 83, 125

Indigo, 37 Ingres paper, 20 Ivory black, 37

Knole Park, 98-107

Lamberhurst Farm, 108–109
Lampblack, 13, 36, 37
Landscape, mood in, 72
Lemon yellow, 13, 37
Light:
balancing of, 56–63
and mood, 72, 79
morning, 125
navigational, 129
on water, 117, 129
Light red, 36
Light-fast pigments, 36–37
Line drawings, tone added to, 18
Loose treatment, control in, 42–47, 132
Lorrain, Claude, 11

Marking pen, sketch with, 18
Masking medium, for white areas, 33
Mere in Winter, 72–79
Mijas, Spain, 112–113
Monastral dyes, 37
Monet, Claude, 36
Mood, to create, 72–79
Moonlight on the Blackwater, 128–129
Movement, to capture, 80–87

Neutral tint, 36, 37

Oast houses, 135

Old Tidal Mill, Birdham, 140-141 Opaque colors, 36 Organization of painting, 13, 41, 48, 98, 126 Outdoor sketching, 18, 20 colors for, 36 Overworking of painting, 41, 71 Oxide of chromium, 36 Paddle Steamer, 80-87 Painting: evaluation of, 14-15 organization of, 13, 41, 48, 98, 126 Palette of colors, 36, 37-40 See also Color Pavne's gray, 36, 37 Pencil sketches, 18 Permanency of colors, 36–37 Phthalo blue, 36, 37 Phthalogreen, 13, 37 Pigments, 13, 36 Pin Mill, 120-121 Plowing in the Fall, 110-111 Precious Bane (Webb), 72 Preliminary drawings, 98–99 Priorities in painting, 41, 48 Prospect of Whitby, 126-127 Prussian blue, 37 Purple pigments, 37

Oast Houses, near Shoreham, 132–133

Quiet painting, impact in, 64-71

Raw sienna, 13,36Raw umber, 13,36Receding space, 24,42,47,63,75,83,110Reflections, simulation of, 67,72,75,91,93,97,139Rembrandt van Rijn, 11Resists, white areas made with, 33Rowneys, 37Royal Eagle, 80

Sailing Craft at Low Tide, Morning Light, 124–125 Sailing Craft Becalmed, 64–71 Sargent, John Singer, 36 Schubert, Franz, 15

Scratching out color, 33 Scrubbing out color, 28, 33 Sea, see Water Sepia, 13, 36 Sequence of procedures, 8 See also Demonstrations Shadows, 61, 63, 99, 101 Shapes, and mood, 72 Sketches, 48 outdoors, 18, 20, 36 painting from, 137 on toned paper, 16 Skies, 22, 41, 43, 64-69, 105-107 active, 80-87, 110, 135 blue, and white clouds, 30 cold, and warm clouds, 31 complicated, washes for, 34 graduated, 35 light, and dark clouds, 29 scrubbing out, 28 strong but subtle, 48-55 tonal balance in, 56-63 Snow in Morning Sun, 56-63 Space, receding, 24, 42, 47, 63, 75, 83, Sponging out color, 30, 32, 33, 49, 53, 129, 130 Staithes, 114-115 Stencil, highlights made with, 32 Stour river, 118 Style, 15 Sullivan, Edmund, 13 Sunglasses, for tonal perception, 17 Sunrise Through Vapour (Turner), 15 Sussex Lane, 130-131 Technical skill, importance of, 8, 10-11 Temperature of colors, 37

Technical skill, importance of, 8, 10-Temperature of colors, 37 See also Cool colors; Warm colors Terre verte, 36 Thames river, 126 Third dimension, 24 See also Receding space Tinted paper, 16, 20–21 Tonal method of painting, 17 Tonal patterns, to vary, 88–97 Tonal values, 16–17 balance of, 56–63, 114, 117 indications of, 18–20, 36

interrelation of, 135 and mood, 72 and receding space, 24, 42 Tone: color and, 26, 27 and line drawings, 18 Toned background: sketches on, 16, 20-21 values on, 25 Tracing technique, 99 Transparent pigments, 13, 36 Tree Lane, 42-47 Trees, 131, 139 winter, 42, 47 Turner, J.M.W., 11, 15 sketching techniques of, 16, 20

Ultramarine blue, 36

Values, tonal, 16–17 interrelation of, 135 and mood, 72 and receding space, 24, 42 on toned background, 25 variations in, 8 Viridian green, 36

Warm clouds, 31, 34 Warm colors, 37, 65–69, 75, 83, 91–93 Washes: granulated, 36, 37, 67, 117, 125, 132, 140 large, 89 planning of, 34 sequence of, see Demonstrations Water: agitated, 87 calm, 67-71, 72-75 light on, 117, 129 Watercolor, as medium, 10-11, 15 Webb, Mary, Precious Bane, 72 Whistler, James McNeill, 15 White areas, 32, 33 and toned backgrounds, 25 and tones, 26, 27 Winsor & Newton, 37

Yellow ochre, 36 Yellow pigments, 13, 36